# GERMANS
# IN NEW JERSEY

# GERMANS
# IN NEW JERSEY

• a history •

PETER T. LUBRECHT

Charleston — London

THE
History
PRESS

Published by The History Press
Charleston, SC 29403
www.historypress.net

Copyright © 2013 by Peter T. Lubrecht
All rights reserved

First published 2013

Manufactured in the United States

ISBN 978.1.62619.054.2

Library of Congress CIP data applied for.

*In memory of my Oma, Gesine Ehlers.*

# Contents

# Preface

A ny history written about a specific group of immigrants has an inherent danger of becoming a long "ethnic whine." Every nationality that comes to America faces prejudice, ostracism and mistreatment. First-generation children don't always understand their parents' need to cling to the "old ways"—whether they are related to custom, clothing, religion or politics—for there is an initial need to reject them and become part of the new country and a modern society. There is also a need to separate from that, which seems foreign and different, including the parents' native language. The research for this book, in an era of very politically correct terminology, led me to believe that there is little difference in negative opinions directed at any race or immigrant group. There are different degrees of animosity; however, there are also commonalities. We all have cultural differences, foibles and stereotypes. We are alike in the human condition. I have tried to present a picture of the Germans who came to New Jersey for many diverse reasons in the light of customs struggles and motivations for leaving their homeland.

The emotional strength needed to uproot all that is yours and bring it to a new country where you do not speak the language is beyond my comprehension. My father chose this country when he was barely nineteen years old. He had a good job in Germany, and he had saved enough money to come here first class on a ship, which his uncle thought would go to Ellis Island. Instead, first-class passengers were disembarked at the Forty-second Street pier before the lower-class passengers were taken to Ellis Island. He sat alone on his suitcase for four hours, waiting for someone to get him—the

image has haunted me for years. Finally, Uncle Christian found him. My father eventually started his new life and job alone in Manhattan, trying with every fiber to become a "true American." He was violently opposed to any force that he felt was against the country he loved. A renewed interest in family history is the catalyst for tracing a heritage, and when that is done, both the good and bad qualities need to be examined. I have tried to avoid the ethnic whining and have tried to be as objective as possible.

This book generated from growing up German. As a child (and still today), I sometimes felt anger and animosity directed at my family background. My surname is decidedly Teutonic. Lubrecht was a name given on the medieval battlefield to a knight (*ritter* in German) and means "bright light of the people—"lubbe" meaning people, and "brecht" meaning bright. There was once a "von" before it, when the family lived in West Prussia in what is now Poland.

There was no hiding my ethnicity in Inwood, an Upper Manhattan neighborhood called the "Fourth Reich" and "Frankfurt on the Hudson" because of the large number of German Jews living in it. In 1947, my first-grade year, I was the only German American in a class of children whose parents were mostly German Jewish refugees. Fifty years later, a former Jewish classmate told me that my family was known as "righteous gentiles," and I felt animosity on only two occasions (and after the fights, the other combatants and I were punished for it by our respective German and Jewish mothers).

I cherish my high school years at the Bronx High School of Science, where I was one of two German American Lutherans in my graduating class of 750. My classmates, 675 of them Jewish, were some of the brightest students in New York City in the 1950s. Our class of 1958 has produced doctors, lawyers, authors, New York City Council members, teachers and college professors. Today, we are proud of our individual heritages and the accomplishments of our class. I have felt little negativity toward my background on their part. When at a fifty-year reunion, in which we discovered that we were discussing the Holocaust for the very first time, we asked why hadn't this topic arisen in high school. The answer was simple: we did not have time, and we were looking in a forward direction, just as we try to do today.

As I progressed through school and New York University, I was not as aware of my own ethnicity as I am now in an age of "encouraged diversity." We were taught to celebrate difference in all cultures and to explore the meanings behind them. Negative German encounters were recently directed

at me by "fellow educators" who were ignorant of German American history. Therefore, as a New Jersey resident, I thought of this book. I felt that the story of the German immigrants should be told.

I want to thank all of the people who provided me with stories and family histories. I found that a personal account often tells the story of a whole group, and therefore, I collected many tales. Thanks to all my family, including my sons Christopher, who did some research, and Pete, a history teacher and high school administrator who has been a sounding board for many years on this topic. Also thanks to my grandson Michael, who sits by my computer before school and wants to know when he can go to Germany; my grandson James, who has to endure "bad German music"; to their mom, Lynn, for being supportive as a fellow German American whose first German words were "Wo ist Bremen?"; to my grandson Jack for his "gaming" input; and most of all to my wife of almost fifty years, Thea, who puts up with this stuff and this time was taken to the Rhineland, only to be snowed in for a day in a hotel where English was an unknown language.

Special thanks to the Germania Park Mixed Choir and all the singers there; the Sussex County Historical Society Museum (my Friday morning hangout); Tina Gehrig for the Oktoberfest photo; Pastor Cheri Johnson at Trinity Lutheran Church in Dover; Tom Ankner at the Newark Library; Kathy Ludwig at the David Library in Washington Crossing; Alex Everitt for the books and information on New Germantown; Nancy Madacsi for her photography information; Valerie Stern, Jim Wright and Pete Chletsos for their support and aid; Myra Snook for the information and tour of Stillwater; Wayne McCabe for help with Camp Nordland; Charlotte and Hans Arndt for German Valley; Armin Wagner for Schlarafia; Phil Kane at the Tewksbury Historical Society; Theo Lohrig for help with the Rhineland and German soccer leagues; Arnold Lange at Germania Park; John Larora at Fritz Reuter Altenheim; Major Michael McGauley, U.S. Army Reserve, for the Hessian information and cemetery visit; Roy and Britta Pridham of Alpine Meats; Barbara Koster of Black Forest Inn; Susan Dreydoppel at Moravian Camp; John Dunado for the Mount Hope information; Steve Cunningham, past president of the Moravian Historical Society; Nancy Kiddoo for Hessian facts; Bob Grabowski at the Stillwater Historical Society; Gregg Kapps at Northeast Computer; Professor Jeff Williamson; Sandy and Ron Knowle for their personal stories and the visit to Omi Margarethe Frerich; Whitney Landis at The History Press; Linda Forgosh at the New Jersey Jewish Historical Society; and all those good people that I have talked to and have forgotten to mention.

# Introduction

*"My country, right or wrong." In one sense, I say so, too. My country; and my country is the great American Republic. My country, right or wrong; if right, to be kept right; and if wrong, to be set right.*

*To be a German now means more than it meant before he belonged to one united nation. He who calls himself a German now must never forget his honorable obligation to his name; he must honor Germany in himself. The German-American can accomplish great things for the development of the great composite nation of the new world, if in his works and deeds he combines and welds the best that is in the German character with the best that is in the American.*
*—Carl Schurz, German Day, June 15, 1893*

German immigrants have been moving into the state of New Jersey for three hundred years, bringing industrious farmers, hardworking merchants and industrialists to the towns and the cities across the state. They first entered in about 1713 and initially spread throughout the rolling hills of the northwestern part of the state, clearing the heavily forested land and turning the rich earth into traditional farms on which to grow grain and raise cattle for the new settlements. They were the millers, the tanners, the dairy farmers and the artisans of the new colony, whose paths of travel from their origins in Germany to the farms and cities of their new state is difficult to trace. Old family records, carefully transcribed into the middle of the family Bible, usually a giant volume hauled laboriously from the old country,

A German family Bible, circa 1747. *Courtesy of the Sussex County Historical Society.*

give some evidence of their arrival. Old land deeds on crinkled velum have a written record of land purchases and sales. Family lore, legends and tales fill local history books.

Pitiful homeland conditions, advertisements from the New World promising opportunity and letters home from families already in the colonies drew immigrants on long trips across the Atlantic to an unexplored territory. In later years, they were seeking refuge from war, famine, depression and persecution. As is the case with most "foreigners," they were clannish and lived in ethnic conclaves, learning little English and therefore drawing the scorn and derision of "Americans."

These are stories that genealogists hear repeatedly and which have been passed down through several generations. Most of the early Germans of New Jersey were said to come from the Palatine region along the Rhine River; however, many of the descendants are ignorant of the areas and towns that were the origins of their families. For the early travelers, the Rhine River was the only avenue for foreign travel. They sailed laboriously down the Rhine to Rotterdam, paying tolls every few miles. Eventually, they were loaded onto a ship in Rotterdam, Netherlands, and shipped to the New World. They came from all parts of Germany, including Wurttemberg, Prussia, Silesia and all the other small duchies and cities. There were no records kept of their origins, and once on board the ship, male surnames were the only ones listed as passengers. According to some personal records, these "German" ships were not welcome in New York Harbor; therefore, they landed in Philadelphia and migrated in all directions from there. They were labeled upon arrival as Palatine Germans because of their journey. Many had left the poor conditions of the Rhine region, but there were travelers from other areas of the country as well.

During the nineteenth century, as the ships were being loaded with human cargo, the travelers' native city and accompanying family members' names were supposed to be carefully recorded; however, many of these were done quickly, with only the county of origin being noted. The port of arrival was New York City, from where the passengers would move into surrounding areas and find their waiting friends and relatives. The early immigrants landed at New York Harbor docks and then eventually at Castle Island, in New York's battery. Ellis Island opened in the late 1800s and became the arrival depot and United States' government point of entry. The facility closed in 1928, after which fewer ships arrived, as air travel became the method of immigration. Detailed records were kept in Germany for the modern immigrant, few as they were. However, earlier pre–World War I records kept in Germany were often destroyed.

When the early eighteenth-century German travelers reached the new land, they were anxious to assimilate into the cultural mainstream and often changed their names to a variation of their original ones. Many could not read or write and therefore adopted what they thought was an English version of their name. For example, Johannes Lautermann of Sussex County heard his name read to him by a clerk as "John Lanterman," which then became the family name of record for generations.

Another family legend is that an ancestor "jumped ship" in a port and then became a citizen after landing illegally. Although in some cases possible, this, too, is usually untrue. Some men, avoiding divorce, left one family in Germany and started another one in the new country. They chose to lose their traceable past and told the story to their children of illegally "jumping ship" so that their connections in Germany were lost.

From the first days in New Jersey, the Germans' trademark industriousness made positive contributions to a rapidly growing new society. However, the negative image of German Americans promulgated by various groups over the years was (and still is) ever present to Americans of German origin and descent, who make up the largest ancestral group in the United States. According to a 2006 issue of the *Atlantic Times*, the modern trend toward tracing roots reveals that 43 million Americans or 15.2 percent of the total population have German roots.[1] Germans were (and probably still are) one of the largest ethnic groups in the state of New Jersey as well. German Americans' contributions to the culture of the United States include Christmas trees and presents, the Easter Bunny, blue jeans (Levi Strauss), Heinz Ketchup, Gerber baby food, the frankfurter, sauerkraut, the pretzel, the bagel, the tuba, the Steinway piano and many others. The kindergarten was founded in the Midwest, with a German inventor supplying the Conestoga wagon to get there. Breweries introduced light lager to Americans, bearing the German names of Schlitz, Pabst, Miller, Anheuser Busch, Yeungling and several others. Famous German Americans came from all professions. Athletes include baseball's George Herman "Babe" Ruth, Heinrich Ludwig "Lou" Gehrig, Honus Wagner, Mike Schmidt, Warren Spahn, Mel Ott, Orel Hershiser, Curt Schilling, Duke Snider and Pee Wee Reese. The basketball world boasts German-born all-star Dirk Nowitski, Syracuse coach Jim Boeheim, WNBA star Rebecca Lobo and legendary Kentucky University coach Adolph Rupp. Many other sports and entertainment figures also boast German heritages, including Olympic gold medalist Michael Phelps, NASCAR's Dale Ernhardt, skier Linsey Vonn, tennis's Steffi Graff, golf's Jack Nicklaus, football's Domenik Hixon (New York Giants) and Super Bowl

coaches Jim and John Harbaugh. The entertainment and the music fields are represented by actors Clark Gable, Fred Astaire, Leonardo DiCaprio and Sandra Bullock. Politicians and presidents came from German stock as well, including Dwight Eisenhower and Barack Obama.

New Jersey history, in particular, includes many of the German American men who helped the country grow. The Roeblings built the Brooklyn Bridge, and Albert Einstein left Germany and settled at Princeton. The state became the home of immigrants coming through "New Bremen" (Hoboken) and German Valley (Long Valley), and as the early years passed, German clubs centered on song, exercise, celebration and education formed across the state. The German Americans introduced physical education and music into public school curriculums. Holiday traditions, important to all Germans, produced Kristkindl Markts during Advent, Oktoberfest and Fashing (Mardi Gras). Thomas Nast, the German-born cartoonist who settled in Morristown, created the modern image of Santa Claus and the symbol of the Republican elephant.

America, the great melting pot, has a history of the assimilation of customs from all incoming cultures. The best and most positive contributions are accepted by a growing and changing nation; however, each entering immigrant group bears an initial stigma. For example, Irishmen saw signs that read, "Help Wanted—No Irish need Apply," while Italians, Jews and Poles could not buy houses in select neighborhoods. Discrimination of African Americans and Latinos continues into the twenty-first century. The German Americans in New Jersey suffered it as well, and as they were absorbed into the culture, World War I and II set back their relationships with their fellow citizens each time. Whether they were called Huns or Nazis, they felt the sting of an anger directed either at a power-happy kaiser or a murderous mad man reflected back on them. First- and second-generation German Americans could not understand this venom.

Emotional reactions can often become difficult to process, and hope for human understanding fades when an anti-German encounter is experienced. Hiding origins and ethnic connections is one way of dealing with overgeneralizations and the stereotype of the militaristic unbending Teutonic persona. Answers to the accusations and negative general impressions of a group of people are countered only by positive actions. The accomplishments, contributions and successes of those who live and have lived on American soil—and particularly in New Jersey—should be revisited to present the positive as well as the negative actions of German American history.

# Chapter 1

# "Die Ausgewanderters": Leaving the Homeland for New Jersey

*The Germans are a quiet, sober, and industrious set of people and are most valuable citizens. They generally settle a good many together in one place, and as may be supposed, in consequence keep up many of the customs of their native country as well as their own language.*
—*Isaac Weld*, Weld's Travels

Germans from all parts of their homeland were motivated by political, social and economic events to make the difficult voyage to America. For over three centuries, Germans traveled across the sea, sometimes with great trauma and difficulty, to start a new life. Some of them believed that they were going to return to the *Heimat*, or homeland, one day after making their fortune or at least after saving enough money to return with a nest egg. Farmers, artisans, adventurers and soldiers landed in Philadelphia, New York, Baltimore or Texas to begin a sojourn to a new home. Germans were originally tribal, but those origins are obscured by a lack of written records. Julius Caesar first called them Germani and viewed them as separate cultures connected by mutually understandable languages. These roots and the evolution of a fragmented country later divided into kingdoms, principalities and free cities is directly related to the manner in which many Germans migrated to America and, in particular, to New Jersey. People from the same areas in Germany founded "clannish" settlements in New Jersey. Bavarians, Saxons and Prussians found each other and settled together until later years, when just being from Germany alone was enough to join others in an ethnic community.

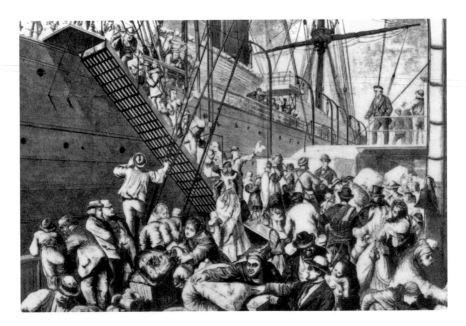

Eighteenth-century German settlers. *Courtesy of the author.*

# THE PALATINE GERMANS

The earliest German settlers in the colonies came to Jamestown, Virginia, in 1608. However, the first real settlement of German immigrants was in Philadelphia in 1683. The first New Jersey Germans came from the "Pfalz," or Palatine, region along the Rhine River. Religious unrest, ill-defined and mobile borders, famine, war and plague in the Teutonic states, principalities, free cities and small governments created a need for people to leave the country and find a better way of life.

Martin Luther, the sixteenth-century architect of religious reform in Germany, followed earlier attempts in England and Belgium to make changes to the Catholic Church. Earlier religious reformers like Jan Hus and others had been executed as heretics, and Luther himself barely escaped from certain death. However, the new sect "Lutheranism," and the French Calvinists caused conflicts all over Europe, which even today is hard to separate into individual religious and territorial battles. The Treaty of Passau (1552) and the Peace of Augsburg (1555) tried to quell the disturbances by allowing each territorial prince to adopt either Catholicism or Lutheranism, depending on his personal choice. If a resident of the area disagreed with it,

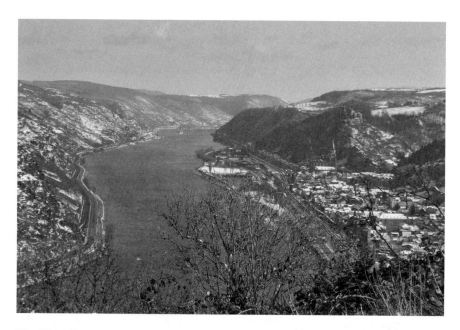

The Rhine River. *Courtesy of the author.*

he was allowed to move into a territory supporting his religious beliefs. The peace did not last.

The Thirty Years War (1618–1648) was an attempt to restore Catholicism to the regions that were Lutheran, and with the decline of the Holy Roman Empire, Germany became divided into *Kleinstaaterei*, or small principalities. The war raged on, destroying the land and populace with the disease that accompanied it. The population was reduced to 10 million people across Germany, severely damaging the Rhineland (the areas of western Germany along the Rhine River). The Peace of Westphalia (1648) was ignored by Louis XIV of France. He chased escaping French protestant Huguenots across the French border into the German cities of Trier and Mannheim, and his army demolished everything in its path.

Johan Ludwig Kübel, a traveling merchant and later Bürgermeister of Heilbronn, was on his way home on January 17, 1674, when he saw the walled town of Wimpfen on fire. As he moved on, he witnessed the Battle of Sinsheim:

> *I saw a battle between the Imperial German Army and the French at Sinsheim in the Palatinate. The latter, despite bigger losses, was the winner because they were in superior numbers. After the victory, the Frenchmen*

*looted and burned the little town of Sinsheim, destroying the mountain road, while fruits of the fields have been destroyed. God have mercy on the poor people! This was the day after the French, under Turenne* [Henri de la Tour d'Auvergne, Vicomte de Turenne—eventually the electorate of the Palatinate] *lost 180 officers and 1,100 men.*[2]

The onset of poor weather and storms caused further destruction. Kübel knew of the concern over Halley's Comet when it appeared, and he wrote on December 16, 1680:

*In the evening at five or six o'clock, I saw a very cruel and terrifying comet star. It has been seen widely elsewhere in other countries. The tail was 60 degrees long, although the star part was not even big, not too bright, but the tail was white, and the white light stayed at 30° overnight. Its meaning is that dear God knows that we should not live in evil, as is Christ's will.*[3]

The combination of natural, political and military forces destroying the Palatinate area motivated a mass migration out of the country into a new land. In 1683, Francis Daniel Pastorius had already led a small party to a village near Philadelphia, aptly christened Germantown. By 1708, broadsides reached the Rhine Valley from the Carolina colony. The German Reverend Joshua Kocherthal made a request for sanctuary to Queen Anne and landed in London in 1708. His homeland continued to be ravaged by Louis XIV, and the British Crown decided to send the refugees to the New World. The West Indies were chosen but were found to be unsuitable for the fair-skinned Germans, who were instead given land that today is Newburgh, New York.

After the initial departures from the Rhine region, immigration became more difficult and more crowded. As 13,500 Germans and Swiss sought passage to England and the colonies, another conflict started with the French. The War of Spanish Succession (1701–1714) brought British troops to the European mainland, allowing (due to the graces of the commander the Duke of Marlborough) the Palatines to journey to England on the returning empty troop ships. The German government put a stop to the exodus by issuing an edict that forbade the Palatines leaving the homeland imprisoning "law breakers" as they journeyed down the Rhine. Their solution was to go overland and avoid the edict.

As life in the Palatine region became more and more violent and dangerous, the city of London became crowded with emigrants camping out and begging in the streets. Ireland was tried as an alternative settlement

Castle and toll stop on the Rhine River. *Courtesy of the author.*

by a sympathetic British government. However, New Bern, North Carolina, was settled because of pamphlets advertising the New World and free land.

King Charles II granted land to William Penn in 1681 as repayment for a loan given by Penn's father. The other objective connected with the land grant was that England could get rid of the troublesome "Quakers." To qualify British claim to land in the colonies, it needed to be populated. Therefore, William Penn issued pamphlets and letters meant to publicize his "Holy Experiment." He printed them in London and sent them to the Palatinate. This long list of advantages and conditions noted:

> *A plantation seems a fit place for those ingenious spirits that, being low in the world, are much clogged and oppressed about a livelihood. For the means of subsisting being easy there, they may have time and opportunity to gratify their inclinations.*[4]

There is no evidence of how well the Palatinate Germans responded to Penn's words; however, colonization started in Germantown, near Philadelphia. Many of the Germans looked for further opportunities, and while some traveled north into western Pennsylvania, others traveled into what is now New Jersey.

# THE JOURNEY UP THE RHINE AND OVER THE WATER

*Man is born free, and everywhere he is in chains.*
—*Jean-Jacques Rousseau,* The Social Contract

Jet travel to modern-day, unified Germany obviously cannot be compared to the journey of the earlier Germans over the Atlantic Ocean. During a six- or seven-hour flight, passengers sleep, eat and watch movies. Ocean transport of passengers was in its infancy in the seventeenth and eighteenth century, and the slow trip featured disease, malnutrition, cramped quarters, official dishonesty and death.

The tales and stories of the early immigrants are buried in family lore and, occasionally, in a diary or old Bible. Many of the travelers were illiterate farmers and workers who had sold everything for a start in a new country. Fortunately, some diarists published their adventures for the pleasure of the readers in the Old World. Gottlieb Mittelberger, Peter Kalm, Andrew

Castle on the Rhine River. *Courtesy of the author.*

Mellick and others included descriptions of voyages and settlement in the novel new atmosphere of the colonies.

Gottlieb Mittelberger was a music master, organist and teacher who journeyed with a group of immigrants to Philadelphia, where he worked as an organist and teacher and then returned to his homeland after three years. He wrote an account of the Palatine immigrants in his *Reise nach Pennsylvanien im Jahr 1750 und Rückreise nach Deutschland im Jahr 1754*. The book was dedicated to the most "Illustrious Prince and Lord, Carl, Duke of Wurtemberg and Teck, Count of Mömpelgardt, Lord of Beidenheim and Justingen, etc. Knight of the Golden Fleece, and Field Marshall, General of the Laudable Swabian Circle, etc."

Mittelberger left in May 1750 from Enzweiblingen, Vaihingen County, Germany, to Heilbronn with a pipe organ to be delivered in Pennsylvania. With this baggage, he started the long journey to the New World like all the other travelers, who were later called Rhinelanders because they all used the Rhine as a first step. Therefore, Palatine Germans in both New Jersey and Pennsylvania were called Palatinates even though they may have journeyed from other parts of the country.

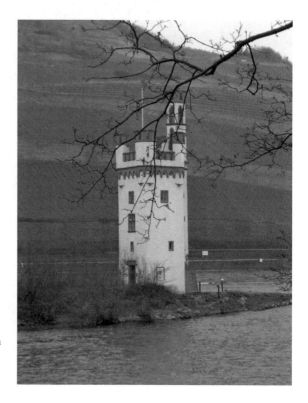

The Mäuseturm (Mouse Tower), located in Bingen am Rhein on the Rhine River, was built in 968. *Courtesy of the author.*

Tollbooth on the Rhine in Gondorf, Germany, constructed circa 1414. *Courtesy of the author.*

Mittelberger's account is one of the few concerning the difficult journey from the homeland, which took seven weeks on the Rhine alone and then fifteen weeks from Rotterdam to Philadelphia. He states:

> *The most important occasion for publishing this little book was the wretched and grievous condition of those who travel from Germany to this new land, and the merciless proceeding of the Dutch man-dealers and their man stealing emissaries, for they steal, as it were, German people under all manner of false pretenses and deliver them into the hands of the great Dutch traffickers in human souls.*[5]

Little is written of this part of early American German history, but all the paths to New Jersey led through Philadelphia and the dangerous conditions along the way. Mittelberger cruised down the Neckar and Rhine Rivers to Rotterdam, Holland, where they boarded a ship to Philadelphia. Mittelberger reported that the journey took from the beginning of May to the end of October.[6] The reason for the delay was the expense of the trip and the number of toll stops along the river, which made the trip last three to six weeks. Upon arrival in Rotterdam, the travelers were detained another five to six weeks, and the money saved for the journey was quickly used up by unexpected expenses. Once the ships were loaded, the passengers were "packed like herrings."[7] Mittelberger wrote:

> *One person receives a place scarcely two feet width and six feet length on the bedstead, while many a ship carries four to six hundred souls; not to mention the innumerable implements, tools, provisions, water barrels and other things which likewise occupy much space.*[8]

Mittelberger reports that the misery began once the ship began to sail and included stench, vomiting, sea sickness, fever, dysentery, headaches, heat, constipation, boils, scurvy, cancer and mouth rot, which he blamed on the over-salted meat and bad water. The raging sea and storms only exacerbated the agony and eventually caused death for many. The deceased were pushed through the portholes, and children rarely survived the voyage. He saw "32 children" die on his ship; measles and small pox took most of them. In 1754, a ship was capsized between Holland and England. The loss of human cargo was desirable to the captain, who tried to abandon the souls in the water. Most of the passengers perished, but some miraculously survived to report the event. In 1752, a ship arrived in Philadelphia with only 21 of the original 340 passengers. Between 1754 and 1755, 22,000 German immigrants landed in Philadelphia. Many of the arrivals found that they

had been swindled after banking their money with an unscrupulous attorney or ship captain and were therefore penniless and forced into indenture.

Finally, at the end of the voyage, the survivors, who had endured hunger and vicious thirst, could not leave the ship until their fare was paid in full. The able-bodied men over fifteen years of age who had paid full passage were marched directly from the ship to the courthouse or town hall to take an oath of allegiance to the Crown of Great Britain. The people who owed money—and by this time, it was routine to be short of the savings accrued— had to remain on board until they were sold and released to their purchasers. The cost of the trip was £10 or 60 florins. Children five to ten years old were half price, while those under the age of five were free. Rich buyers traveled from distances as much as forty hours away to buy the healthiest specimens. Years of service were bartered for repayment of expenses. Adults were indentured for three to six years, and children until they were twenty-one. Children could serve to pay their parents passage, but the best bargain was the five- to ten-year-old who had come at half price but had to be in service for eleven to sixteen years. The worst cases were the adults who lost a spouse on the ship after it had made half of its voyage and then had to serve two complete indentures to pay for both fares. Children orphaned on the voyage had to stay in service until they were twenty-one years old. The "redemptioners," as they were called, faced a life of partial or full slavery. On April 4, 1776, the same year in which the Declaration of Independence was written, the following advertisement appeared in the *Pennsylvania Messenger*: "A young girl and maid-servant, strong and healthy; no fault. She is not qualified for the service now demanded. Five years to serve."[9] In September 1786, the *Pittsburgh Gazette* ran the following ad:

> *To be sold. (For ready money only.) A German woman servant. She has near three years to serve and is well qualified for all household work. Would recommend her to her own country people, particularly, as her present master has found great inconvenience from his not being acquainted with their manners, costume and language. For further particulars, enquire at Mr. Ormsby's in Pittsburgh.*[10]

These indentured new arrivals had a life of hard and constant work that included clearing land, felling trees and building fences. Potential indentured servants were separated from their family, manhandled and sold in Philadelphia on the same auction blocks as the African American slaves. But the life they faced was still better than the one they had left.

## Chapter 2
# Settlements in Northwest New Jersey

G erman family memoirs include stories about the founding of the early settlements in New Jersey. Today, industrious German farms can be found in the same places as they were when built in the early and mid-1700s. A drive through these communities transports the traveler back into an earlier age. The Native Americans originally populating these areas are long gone, but their heritage remains in place names. Historical accounts differ in ascertaining the first German town in New Jersey. One source states that in 1709, the Germans that had settled in New York were being "badly treated" and so moved on to Pennsylvania and, eventually, New Jersey. Peter Kalm, the Swedish traveler and botanist, wrote:

> *The Germans all preferred to settle in Pennsylvania because they had been ill-treated by the authorities in New York, whither they first inclined to settle. Many had gone to that colony about the year 1709 (say 1711) and made settlements on their own lands, which were invaded under various pretexts. They took great umbrage and beat some of the persons who were disposed to dispossess them. Some of their leading men were seized by the government. The remainder, in disgust, left the country and proceeded to settle in Pennsylvania.*

For whatever the reason, once the voyage from the Rhineland ended in Philadelphia, some stayed there, while others headed north into Pennsylvania, where they became Pennsylvania Germans, known as Pennsylvania Deutsch

Stone houses in Grimdorf, Germany. *Courtesy of the author.*

(or today, Dutch). After a stay in Germantown or Philadelphia, farmers headed up the Delaware River into northwestern New Jersey, founding towns in what are now Hunterdon, Morris, Sussex and Warren Counties. Scattered farmers journeyed into other areas, and eventually the German settlement in New Jersey extended from the Delaware River to Hackensack, German Valley (now Long Valley) and New Germantown (now Oldwick). Most of the population was centered between Lambertville, Newton (then Sussex Court House) and the Delaware and Bound Brook.[11] Other farmers settled in other areas of New Jersey, some as far north as Remmerspach (Mahwah), Eulenkill (Hanover), Elizabethtown (Elizabeth), Mountain Church, Rackeway (Rockaway), Amwell and as far south as Trenton. Their farms and stone houses were built as replicas of those in the Rhine Valley. The durability of these houses built three hundred years ago is a testament to their workmanship. Their farms stretched across the landscape, dotted by vintage houses, and in Chester, one mill can still grind meal.

# NEW GERMANTOWN (OLDWICK)

Most of the early immigrants were Evangelical (Lutheran) or Catholic; however, according to Mittelberger, there were openly atheistic settlers and also members of the "reformed" sects. The early churches, however, were closely tied to the settlements and were built at about the same time of origin of the communities. The remains of these old churches stand on the modern landscape next to graveyards that tell silent stories of the lives of the early Germans.

New Germantown was one of the earliest settlements formed by the Germans from Germantown, Pennsylvania. It was possibly one hundred years old when it was incorporated in 1798 as part of Tewksbury. An early history of New Jersey, written in 1846, tersely describes the locale:

> *6 miles long, five wide; bounded by Washington, Morris Co.; E. by Bedminster, Somerset Co.; S by Readington; and W by Clinton and Lebanon. The northern part is mountainous; the southern fertile, and well cultivated. It is drained by the Rockaway River and its tributaries and Lamington River, which forms its eastern boundary. There are in the township 9 stores, 4 grist m., 5 saw m., cap in mannufac. $7,450; 8 schools, 274 scholars. Pop. 1,944. [It] is in the SE. part of the township, on the road from Somerville to Schooley's Mountain. 14 mile NE. from*

View of New Germantown. *Courtesy of the Sussex County Historical Society.*

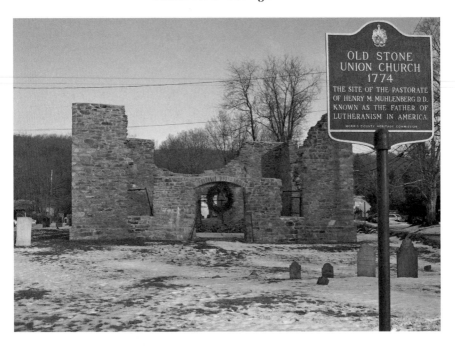

Old Stone Union Church was the 1774 pastorate of Henry Muhlenberg, the father of American Lutheranism. *Courtesy of the author.*

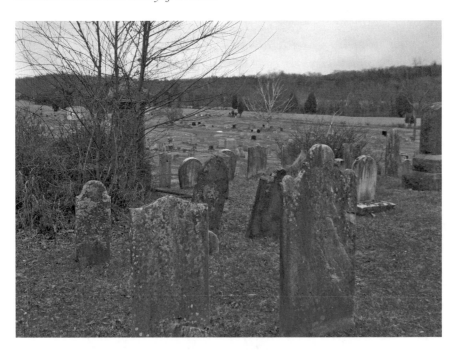

Old German cemetery in Stillwater, New Jersey. *Courtesy of the author.*

*Flemington, and 45 miles from Trenton. The village is on a slight acclivity descending to the N. It is built on several streets, at right angles to each other. The surrounding county is hilly, and very productive of wheat and corn. Much lime is burnt and used in the vicinity; and agriculture has in consequence, much improved within the last 15 years. It contains 4 stores, a tannery, 1 wheelwright, 1 cabinet maker, 2 blacksmiths, 2 saddlers, 3 shoemakers, 1 cooper, 2 tailors, an academy, a Methodist and a Lutheran church and 55 dwellings.*[12]

Settlers here were men of faith, and while establishing farms, mills and tanneries, they also founded the Lutheran and German Reformed Churches. Most of the early history of this community is described in a very long book written by Andrew Mellick entitled *The Story of an Old Farm; Or, Life in New Jersey in the Eighteenth Century.* With a genealogical appendix, his account was dictated and written in 1889 by one of the descendants of first settler Johannes Mölich.

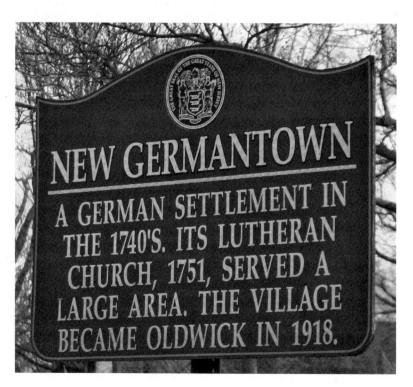

New Germantown, New Jersey. *Courtesy of the author.*

Lutheran Church in Bendorf, Germany. *Courtesy the author.*

The Mölich family came from Bendorf, a town near Koblenz on the Rhine River, and settled in Philadelphia, moving to New Germantown several years later and joining other early settlers Lucas Dipple (from Hesse), David King, Jacob Eoff (from Grossheppach), John Appelman, (Hesse Darmstadt) Leonard Streit, Conrad Meizner, Johann Balthazar Pickel (Bad Durkheim), Jacob Klein and several others, including their own relatives.

Johannes Mölich, the founding father of this community, landed in Philadelphia aboard the ship *The Mercury*, sailing under Captain William Wilson, and his descendant Andrew recorded his first impressions of Philadelphia, including an account of slave sales in front of a tavern. He had no reaction to the appearance of black slaves because he was used to the forced servitude of the indentured. As the number of German farms increased in New Jersey, the use of slaves became commonplace. During this time, there were sixteen thousand black slaves in New Jersey. The use of the word "black" is important here, as the white slaves could also be kept as "life-time servants."

Mölich prospered in the new land, buying his first farm in Greenwich Township and then another in Warren County in 1758 before finally settling

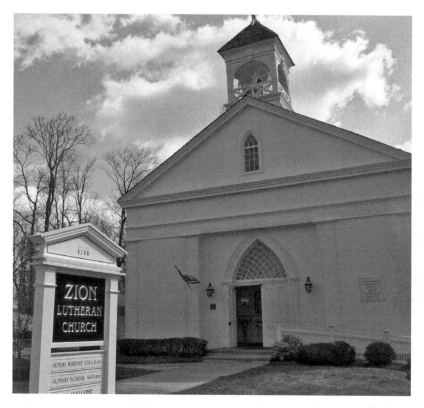

Zion Lutheran Church, Oldwick, New Jersey. *Courtesy of the author.*

in New Germantown. Johannes signed a document for a bond to build the first church in 1757,[13] and soon thereafter, the church celebrated its first communicants. It was rebuilt in 1750 and again in 1830 on the ground where it is today. Zion Oldwick was formed for the Lutherans who had settled in the area and is now more than 250 years old. In the twenty-first century, the church supports good works across the state, including "Edna's Haven" at Trinity Lutheran Church in Dover. Both churches, founded by immigrant populations (in Trinity's case, Swedish and German) now help the homeless and migrants in an urban community. Trinity, only 125 years old, serves close to thirty-nine thousand meals per year to those in need. Both churches were instrumental in starting the Drop-In center as a haven for those in need.

The stories of the founding of Zion, which was modeled after the parishioner's home church in Bendorf, Germany, are plentiful and help chronicle the growth of the community. Its first pastor was Justus Falckner,[14]

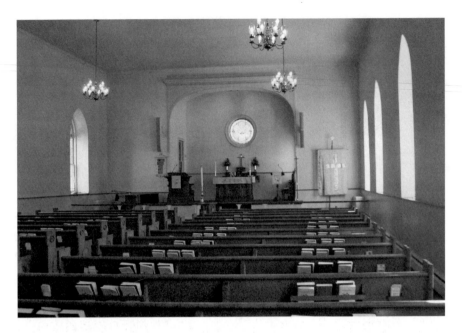

Interior of the Zion Lutheran Church. *Courtesy of the author.*

a German immigrant circuit preacher, who on June 24, 1705, recorded the following baptism in New York City: "Maria, the daughter of Are and Jora Van Guinea, colored people, born about February; both Christians of our congregation. Witnesses: Jochem Ruloffsen and the child's parents."[15] In his account, Mellick chronicles the many Lutheran pastors that traveled to and from this church and predominantly Lutheran community—although ironically, the first baptism was held in the home of a freed slave. Mellick writes, "There was a Christian Lutheran meeting mentioned in these parts as visited and doubtless organized by Rev. Justus Falckner, and that, singularly enough, was at the house of a negro, at which a white child was baptized."

Stories also include the adventures of some of the missionaries and ministers in the area who helped establish the formalization of religion and education, for the German colonists were no different from their British counterparts, taking every measure to include sound education and religious instruction and to avoid their children becoming "cultural barbarians."

By 1767, Peter Muhlenberg, a famous Revolutionary War officer and the eldest son of the famed Lutheran patriarch Henry Muhlenberg, arrived as the cleric for the newly formed Zion Lutheran Church, where he served for

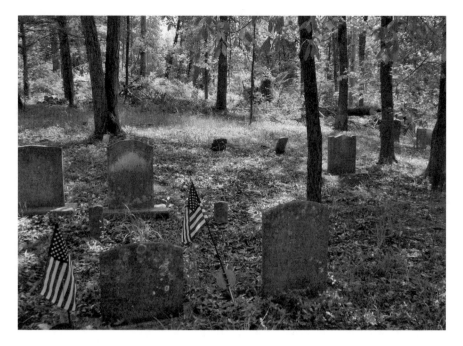

German slave cemetery in Lamington, New Jersey. *Courtesy of the author.*

three years. He later returned to the town as a soldier in the Continental army. He had answered the call to a church in Virginia, where he preached his famous "A Time for War" sermon, during which he tore off his clerical robe to reveal a Continental uniform. Against his father's wishes, he went on to fight in the Revolution, finishing at Yorktown in the defeat of Cornwallis.

Wilhelm Anthony Graff, a Bavarian Lutheran of Grünstadt, Germany, preached for thirty-four years in both German and English, a language that he never fully grasped. His sermons were linguistic adventures in which he often stumbled over the English words. Once, while preaching a sermon on Adam and Eve, Graff could not find the right word for "serpent." He hesitated and finally blurted out "Dot old…dot…dot…old Tuefel, der shnake." Mellick indicates that despite his language difficulties, Graff was a wonderful pastor.[16] The church has remained in the center of the community since its origins and is still attended by many of the descendants of the original settlers.

Johannes Mölich was a tanner, and for his trade, he had to find land near a body of water. He purchased this land 1751, and over the years, it became known the "old farm." The original owners were the Naraticongs, a clan of

The Old Stone House in New Germantown. *Courtesy of the Sussex County Historical Society.*

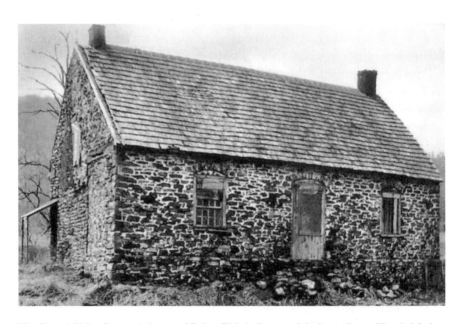

The Round Valley Reservoir home of Baltus Pickel. *Courtesy of the Sussex County Historical Society.*

the Native American Lenni Lenape, who named the land that lay between the Hudson and Delaware Rivers (Lenni-Whittuck) the "Scheyichbi."[17] Mellick emphatically states that the German settlers bought their land from the natives, one of whom he described as "a dusky Indian, with wampum belt and feathered crest, lurking beneath the shadows of the grand congregation of trees of primitive Bedminster."[18] The early German settlers were proud of buying and not taking their land from the earlier Native American owners.[19]

The colony of Rhinelanders grew and prospered. They were able to establish trade with other towns and supply their products to cosmopolitan Philadelphia. However, in February 1774, despite the oath of loyalty they had sworn to King George III, the colonists were developing distrust and resentment for their adopted mother country. According to Mellick, the March 1774 Boston Port Bill caused New Jersey's provincial assembly to appoint a nine-man general committee in February 1774 to formalize the concern of the settlers. Loyalist governor William Franklin (Benjamin Franklin's illegitimate son) refused to convene the assembly when asked by this committee to do so. He declared that there was no "public business of the province which can make a meeting necessary."[20] In June and July 1774, the counties in New Jersey began to gather to organize a defense and first elected members to the Continental Congress, scheduled to meet in September of that year.

The "sticking point" was the loyalty oath that the immigrants had taken, and therefore, the "Provincial Congress" and the Council of the State of New Jersey met on July 21, 1774, in New Brunswick and passed a resolution declaring loyalty to King George III but not to the actions of the English Parliament:

> *Accordingly, we do, in a most sincere and solemn manner, recognize and acknowledge his Majesty King George the Third to be our lawful and rightful Sovereign, to whom under his royal protection in our fundamental rights and privileges, we owe and will render all due faith and allegiance.*
>
> *We think the several late Acts of Parliament for shutting up the port of Boston, invading Charter rights of the Province of the Massachusetts Bay, and subjecting supposed offenders to be sent for trial to other Colonies, or to Great Britain; the sending over an armed force to carry the same into effect, and thereby reducing many thousands of innocent inhabitants to poverty and distress; are not only subversive of the undoubted rights of his Majesty's American subjects but also repugnant to the common principles of humanity and justice.*[21]

The American battle for independence affected this area of German settlements during British invasions and caused great consternation among the communities. Hard times were visited upon the populace. American general Nathanael Greene wrote the following to his wife, Catherine:

> *The Tories are the cursedest rascals among us—the most wicked, villainous and oppressive. They lead the relentless foreigners to the houses of their neighbors and strip the poor women and children of everything they have to eat and wear; and after plundering them, in this sort, the brutes often ravish the mothers and daughters, and compel their fathers and sons to behold their brutality; many have fallen sacrifices in this way.*[22]

The towns and farms endured the passage of British troops, as well as battles and the trips made by Continental soldiers. After the war, New Germantown returned to building farms, schools and churches. As the years passed, men went off to war in 1812, 1849 and 1860. The post–Civil War years saw a large part of New Jersey industrialized while New Germantown remained untouched as a tranquil rural community. Over the passing years, grain farms turned into horse farms in the rolling hills and large rural expanses of Hunterdon County. The pressure of anti-German sentiment caused by the Great War in 1919 forced the town to change its name from New Germantown to Oldwick (meaning "old town").

Despite the apparent affluence in modern Oldwick, a drive down the main street leads to Zion Lutheran Church, whose spire still points proudly to the sky, standing in the midst of an early churchyard holding the remains of the founding "old Germans." The interior of the church, containing an ancient organ in its choir loft, has a stark simplicity that reflects the faith of the founding fathers. The town also has a strictly regulated building code to ensure the integrity of the historic scene. A drive on the roads in any direction provides a beautiful panorama of the New Jersey landscape, which, in spots along Raritan River, resembles the Rhineland origins of the first settlers.

## STILLWATER AND SURROUNDING AREAS

The small towns of Stillwater, Johnsonburg, Newton, Walpack, Frelinghuysen, Green and Tranquility are all close to each other in the Warren and Sussex

County area, which was later divided into the two counties it is today. The chronicles of early writers are the best accounts of the beginnings of these towns. *Historical Collections of the State of New Jersey* (1844), by John W. Barber and Henry Howe, describes the town of Stillwater, founded in 1824:

> *Stillwater was formed from Hardwick, Warren Co., in 1824. It is 7 miles long, with an average width of 5 miles; bounded NE by Newton, SE by Green, SW by Hardwick, Warren Co., and NW by Walpack. There are in the township, 3 stores, 4 grist m., and 3 saw m., cap. In manufac. $32, 675, 12 schools, and 300 scholars. Pop. 1476. The surface is generally hilly, and the Blue Mountain runs on the NW boundary. New Paterson on Swartswout's Pond, 5 miles W. of Newton, is a small but thriving village which has sprung into existence within a few years. It contains a store, an extensive tannery, 2 sawmills, and about 20 dwellings.*[23]

Paulinskill River, Stillwater, New Jersey. *Courtesy of the author.*

The Reverend Caspar Schaeffer, MD, was an early genealogist and historian who wrote an account of his memoirs and reminiscences together with sketches of the early history of Sussex, New Jersey, in which he tells of the settlement of this little town, which looks today as if time and the wear of the years have left it alone. Schaeffer was a second-generation German American minister born in 1784 in Stillwater, New Jersey. His grandfather, Johan Peter Bernhardt, had come from Kerzenheim, Germany, and after some detours, to the Stillwater valley. The Schaeffer and Bernhard families left Germany for the same reasons that the others from the Rhine did. They all came to Stillwater via London and Philadelphia, where John Peter Bernhardt, ten years after they arrived, purchased three farms, one for each of his daughters. They settled on the Tehoénetcong (Paulinskill) River near the present center of Stillwater.

Caspar, the "family historian," wrote his memoir in 1855. He had collected stories about the life in the early settlement of Stillwater connected to his family genealogy. He begins with a description of the preparations that the original settlers had to make to be able to farm. The first difficulty was clearing the heavily wooded land for the growth of grain. Old Caspar also constructed a mill on piles in the stream near the Paulinskill River, which is

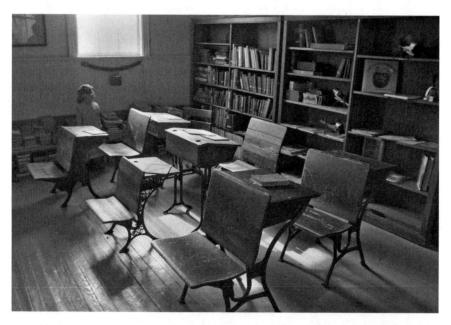

Old schoolhouse in Stillwater, New Jersey. *Courtesy of the Stillwater Historical Society.*

hardly large enough to be called one. However, the river did serve over the years as a source of power and transportation for these German settlers. Schaeffer discovered that during the spring swell he could navigate the river down to the Delaware and on to Philadelphia with flour and then return to the town with dry goods.

For the German settler, part of the attraction to Stillwater was the native limestone, which was used for building houses, as well as for fertilizer and as a paint base. Several colonial limekilns are hidden in the woods along the country roads. Limestone was processed and added to manure as a soil "sweetener," with the burning of the stone in the pits being part of the farmer's fall chores. Lime was used by tanners and as a white wash for interiors and was an integral part of folk remedies, including those for the cure of burns, sore throat, gangrene and swelling. It was even used in wart removal. If mixed with honey and taken internally, it was supposed to cure backaches and assuage the itches of poison ivy; however, it was also used to kill moles and repair glass.

The kilns for processing the stone were built with native stone along a roadside, with access to the top of the pit via an earthen ramp. The limestone was dumped in and loosely packed to allow air to keep the fire burning from below it. These furnaces, now two to three hundred years old, are still usable—a testament to the construction skills of the ancestors.

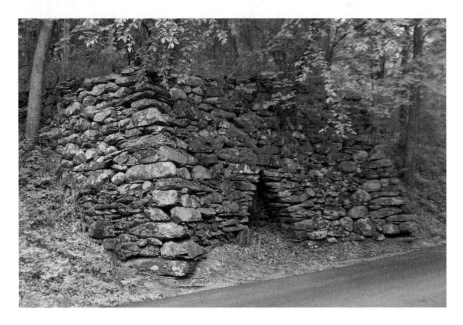

German lime kiln, Stillwater, New Jersey. *Courtesy of the author.*

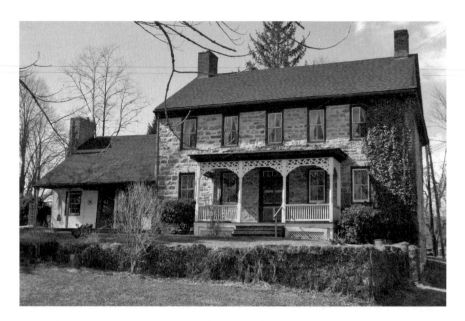

Shaver Homestead, Stillwater, New Jersey. *Courtesy of the author.*

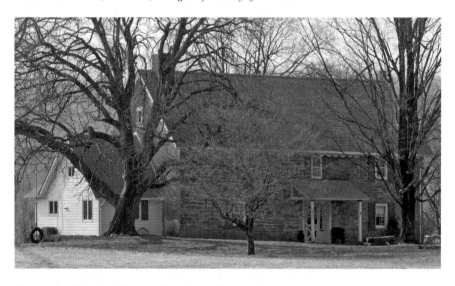

Wintermute Farm in Stillwater, New Jersey. *Courtesy of the author.*

Quarried stones were used for building houses, which were small at first but expanded as the family grew. Most of these early houses are still lived in today, evidencing the colonial craftsmanship. Old Caspar's house is still in daily use as a residence, and the nearby former slave quarters

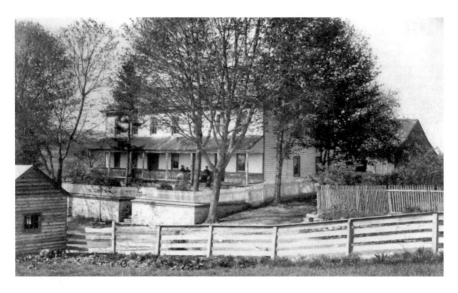

Wintermute Farm in Stillwater, New Jersey, circa 1895. *Courtesy of the Sussex County Historical Society.*

(which curiously boasts two stories and a double porch) overlooks the Paulinskill River.

This community's industry was focused on the farming and milling of grain and lumber production in a sawmill along the Paulinskill. The settlers planted fruit orchards and grape arbors that resembled the vineyards along their native Rhine River. The family members and their slaves provided the daily hard labor for these rural industries. Caspar Schaeffer wrote:

> *My father and his brothers all held slaves of the African race, more or less. My father held at one time eight or ten of them. The system, however, existed here in its milder form. The slaves and white laborers associated and worked together and in all respects fared alike, only that in lodging and messing they were both separate. This was the only distinction in regards to their domestic treatment; the blacks feeling as much interest in the prosperity of the farm and stock as others.*[24]

Indentured servants, who lived with the black slaves, had a time limit on their term of servitude. The "Africans" did not until February 15, 1804, when New Jersey enacted the Act for the Gradual Abolition of Slavery, which provided that females born of slave parents after July 4, 1804, would be free upon reaching twenty-one years of age, and males upon reaching

twenty-five. The hidden content allowed that children born before the deadline could be farmed out as laborers until proper age. The slave owners could, however, sell their slaves to farmers in the South, where slavery was still legal. The evidence of slavery in the areas of Stillwater and New Germantown can be seen in the slave cemetery in Lamington, New Jersey. Free blacks could own land and join the military, but they could not vote for many years.

The Stillwater settlers were primarily German Reformed Church members, many of whom became Presbyterians and Methodists as the churches began to be built in the area. Education of the children and proliferation of the faith are traditional German conditions. Circuit preachers used houses and schools as early churches until a building was constructed. The first German Reformed Church, built in 1777, used to stand at the entrance to the cemetery, but all that is left is a faded stone marker.

Stillwater suffered through rough and dangerous times during the French and Indian War. The Schaeffer families had to build stockades around their homes for protection from hostile Native American tribes. After the November 3, 1762 Peace of Paris put an end to the war, the area had a few years of peace until the Revolutionary War, when again the Lenni Lenape, now on the side of the British forces, terrorized the town. Fortunately, they were not armed with muskets and could be scared away by gunfire. At this time, most of the immigrants and their descendants were staunch Whigs

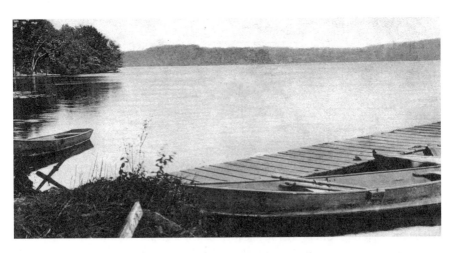

Bunn's boat landing, Swartswood Lake, New Jersey. *Courtesy of the author.*

and served in the local militias in the fight against the king. Graves of the veterans of both these wars are still in the old cemetery.

Today, Stillwater looks as if the horses and buggies have just left. One resident says that he loves the town because someone who lived there 250 ago could return and find it still looking the same.

The old German graveyard, located on a small rise looking up at the Blue Mountains, overlooks the valley filled with the gravestones of the earlier settlers and veterans of all the American wars. Caspar Schaeffer's tombstone, dated 1784, stands out as one that has absorbed the winds and rain of two hundred years with a name and identity clearly legible.

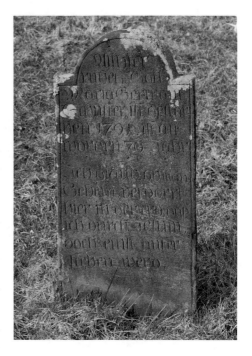

Colonial German grave in Stillwater, New Jersey. *Courtesy of the author.*

# Long Valley

There are conflicting stories about the origin of Long Valley, originally named German Valley. One history sets the date as 1705, making this town the oldest German settlement in the state. However, later historians place the arrival of the Germans between 1720 and 1730. No matter the date, the early founders had traveled from persecution at Wolfenbüttel and Halberstad to the town of Neuwied, where they were welcomed by the Count of Wied. After a short while, they left to go down the Rhine on the terrifying journey to Rotterdam, finishing with a forced stop at Sandy Hook, a refuge in Delaware, before finally ending in Philadelphia. According to these early tales, the Germans were headed overland to New York State through the western part of New Jersey, and upon finding the beautiful country, they decided to settle there.

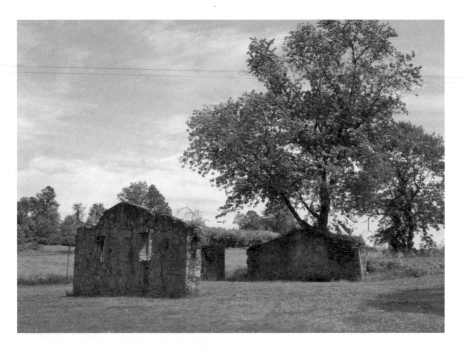

Long Valley, formerly German Valley. *Courtesy of the author.*

German Valley, 1895. *Courtesy of the Long Valley Historical Society.*

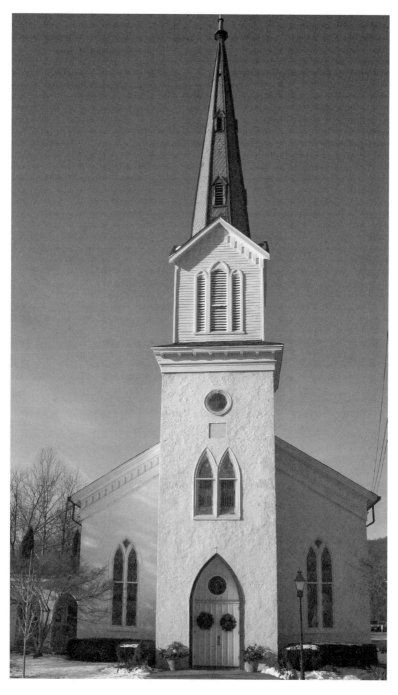

Zion Lutheran Church, Long Valley. *Courtesy of the author.*

In this beautiful, low-lying valley near Chester, New Jersey, at the base of Schooley's Mountain, the Germans built their first church of logs in 1747, which reportedly was used by both the Lutherans and the German Reformed residents. The pastor was shared with New Germantown, nine miles away. In 1774, during the ministry of "the father of American Lutheranism in America" Henry Muhlenberg, they decided to build a new stone church now called the Old Stone Church. Although it stood for over a century, only the beautiful ruins are left standing in the middle of the country churchyard burial ground.

In 1832, the two congregations sharing the stone church decided to separate, and the German Reformed Church became the Presbyterian Church. Ground was broken for Zion Lutheran Church, with the cornerstone set in place on Whitsun Monday, June 11, 1832. The bill for the construction was $2,144.38 and was fully paid by subscription except for $230.88.[25]

# Chapter 3

# The Moravians

The religious sect of Moravians arrived in New Jersey at approximately the same time that the Palatine Germans did. They were originally from the German towns of Fulneck, Berthelsdorf, Gersdorf, Gestersdorf, Kunewalde, Klandorf, Stechwalde, Seitendorf, Zauchtenthal and Dresden. Often considered a "cult" or a splinter group of very strict Lutherans, the Moravians believed in a purer form of their faith. Lutheranism was too dry and not militant in its pursuit of salvation through missionary work and evangelistic outreach. The sect was originally from Moravia (now the Czech Republic), a province neighboring Bohemia, but fled to Saxony in Germany to escape persecution. Their Latin name is *Unitas Fratum*, or the Unity of the Brethren, which combined the teachings of the martyred Jan Hus with that of the Waldenses, the earliest of the revolutionary pre-reformation sects. They had to conceal their faith for two hundred years because of persecution.

The German-speaking Moravians fled from Moravia to the estate of Count Nikolaus Ludwig von Zinzendorf, a pious nobleman. On the request of their leader, Christian David, they were allowed to settle on Zinzendorf's lands in Saxony, then Upper Lusatia. They were dedicated to missionary work and established a community called Herrnhut on the count's lands. In two short years, the Moravians set out to Christianize the heathen world. Unlike their Palatine brothers, they weren't running from bad times and poverty; their desire was to convert the entire world to Christianity. Zinzendorf used his royal connections to help send teams to the Caribbean, England, the West

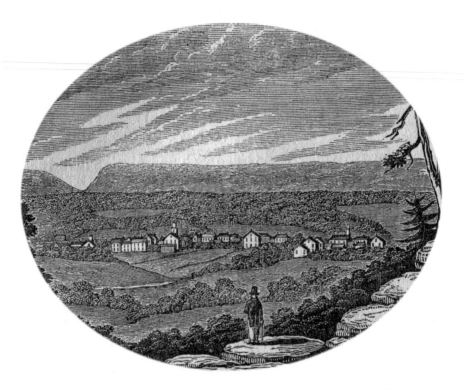

A view of Hope, New Jersey, from Jenny Jump Mountain. *Courtesy of the Sussex County Historical Society.*

Indies, Greenland, North and South America, the Arctic, Africa and the Far East over a period of just thirty years.

The first sect of Moravians landed in Georgia and then migrated to a tract of land in Pennsylvania, where their purpose was to convert the Iroquois Indians. Count Zinzendorf, himself, led the small community of missionaries to what is now Bethlehem, Pennsylvania, so named since it was established on Christmas Eve. Their mission was to gather all the German Protestants together to build churches and schools, as well as to work with the Native American Iroquois tribes. Itinerant preachers rode the circuit of the communities and reached Iroquois tribesmen as far away as New England.

The communities functioned under a system known as the Great Economy, which provided economic support by having everyone work for the communal good. Men, women and children were separated into groups called "choirs," a word that in the Moravian sense is derived from the Greek word "group." The choirs were housed together as part of the ministry to assist one another in spiritual growth and in the sharing of responsibilities.

Choir members worshiped, ate, slept and worked within the group. On Sunday, all of the choirs came together for community worship.

Peter Worbass, who would become the first town administrator for Hope, New Jersey, was a "brother" from Jutland, Denmark, which was loosely a part of Schleswig-Holstein during the eighteenth century. Worbass was a missionary sent to the Pennsylvania town of Gnadenhütten (present-day Lehighton) and was one of the few to escape a massacre of eleven missionaries and converted Lenapes on November 24, 1755, during the French and Indian War. There are conflicting accounts of whether the attackers were other Native Americans or white settlers. The mission village was destroyed, and only four of the fifteen residents escaped. The Gnadenhütten mission was established in 1746 on a tract of land north of the Blue Mountains where the Mahoning River flows into the Lehigh and in 1748 was ministering to over five hundred Native Americans.

Benjamin Franklin was sent to Gnadenhütten by the colonial government to "take charge of our Northwestern Frontier, which was infested by the enemy, and provide for the defenses and inhabitants by raising troops and building a line of forts."[26] He traveled first to Bethlehem, accompanied by his son, to take over the construction of forts for security and safety. From there, he traveled to the "desolation of Gnadenhütten, where they buried the dead." He commented on the practices of the Moravians:

*While at Bethlehem, I inquir'd a little into the practice of the Moravians. Some of them had accompanied me, and all were very kind to me. I found they work'd for a common stock, ate at common tables, and slept in common dormitories, great numbers together. In the dormitories, I observed loopholes, at certain distances all along just under the ceiling, which I thought judiciously placed for change of air. I was at their church, where I was entertained with good musick, the organ being accompanied with violins, hautboys, flutes, clarinets, etc. I understood that their sermons were not usually preached to mixed congregations of men, women, and children, as is our common practice, but that they assembled sometimes the married men, at other times their wives, then the young men, the young women, and the little children, each division by itself. The sermon I heard was to the latter, who came in and were plac'd in rows on benches; the boys under the conduct of a young man, their tutor, and the girls conducted by a young woman. The discourse seem'd well adapted to their capacities and was deliver'd in a pleasing, familiar manner, coaxing them, as it were, to be good. They behav'd very orderly*

*but looked pale and unhealthy, which made me suspect they were kept too much within doors or not allow'd sufficient exercise.*

*I inquir'd concerning the Moravian marriages, whether the report was true that they were by lot. I was told that lots were use'd only in particular cases; that generally, when a young man found himself dispos'd to marry, he inform'd the elders of his class, who consulted the elder ladies that govern'd the young women. As these elders of the different sexes were well acquainted with the tempers and dispositions of their respective pupils, they could best judge what matches were suitable, and their judgments were generally acquiesc'd in; but if, for example, it should happen that two or three young women were found to be equally proper for the young man, the lot was then recurred to. I objected, if the matches are not made by the mutual choice of the parties, some of them may chance to be very unhappy. "And so they may," answer'd my informer, "if you let the parties choose for themselves;" which, indeed, I could not deny.*[27]

Moravian missionaries from Bethlehem often traveled across the Delaware River into New Jersey to convert the Native Americans. On these journeys, they stayed at the farm of Samuel J. Green Jr., a land surveyor and wealthy landowner, and his wife, Anna Abigail. Samuel was converted to the Moravian beliefs and in 1749 was baptized with his family into the church in Bethlehem. Their friendly Native American neighbors were the reason for the preachers' visits in the first place, and the connection with the Greens progressed because of their friendly relations with the tribespeople. In 1749, when the French and Indian War came to New Jersey, the natives warned them to escape because of the danger of attacks, so the family moved temporarily to Emmaus, Pennsylvania.

While living in a Moravian community, the Greens became more and more attached to them—so much so that Samuel offered the Bethlehem Moravians his entire land holdings to be used for a New Jersey settlement of the brethren, similar to the one in Bethlehem. The Moravians, as was their custom, prayed over the offer and decided "by lot" to refuse the offer and purchase the land instead. The Greens were given £1,000 pounds cash and the use of the house and garden, with free firewood and two cows for life. The first to move in to the newly established Moravian community was Peter Worbass and his family. Since he was an experienced innkeeper in Bethlehem, Worbass was made the first manager of the settlement. His wife, Anna Marie (born Schemmel), was the daughter of a tanner of "red leather" from Vaihingen on the Enz in Württemberg, Germany. She was an

extremely devout woman who had found her faith at a traveling missionary meeting in southern Germany. The reflection of her deeply rooted faith in Jesus and her Moravian beliefs are stated clearly in her Moravian epitaph, which she wrote to be read at her funeral:

> *From that time on, I walked the path of a blessed sinner through His grace and support. Although sometimes something of the remaining sinfulness came to the fore, I always found with Him comfort, help and advice. My worldly business was whatever turned up in the economy, and bitterly I was a cook for the sisters[28] for two years in the Sisters House. In 1758, it was put to me that I should change my state, and I gave myself up to the will of the dear Saviour, and on July 29, I was joined in holy matrimony to the single brethren Peter Worbass. The dear Saviour accompanied me into this state with his dear nearness and made of the conditions connected with this state a blessing to me. In December, we went to live in Gnadenthal* [Gracedale, Pennsylvania], *where the dear Saviour gave me a little son with the name of Joseph. In 1760, we returned to Bethlehem to the newly built inn to start a business. From there, we came to the inn across the Lecha. We were there for only four months; then in 1762, we came to live in the Bethlehem mill. There the dear Saviour gave me my second son, named Werther. There I had an especially peaceful and blessed time. The dear Saviour gladly let Himself be known to me in grace. In 1769, we came to the Jerseys, now named Hope, to be in charge of the business. It was a little hard for me there in the business, which I was not used to, but the dear Saviour made everything bearable and easy for me through his frequently unexpected visitations of grace and His dear nearness. In 1771, we were called away from there and were told to move up to Nazareth and to live for ourselves up there. I became downcast and cried and held myself to the Saviour in shame. He let me know that it was his will, and I was comforted by him.[29]*

Her writing shows a personal relationship with Jesus as her savior that she believed, as did all Moravians, came only after an "awakening" to personal sin. Her father died, as she said, in "late grace." She left her family and traveled to America in the service of Georg Schlosser, and after her arrival in New York, she went to Bethlehem, Pennsylvania, where she was released from his service to become a maid for the choir of Single Sisters.

When Anna was married to Peter Worbass, her betrothal was done "by lot." For this process, the Moravians presented three glass cylinders to the

church elder, each one containing a slip of paper. One slip was blank, one read "nein" (no) and the other read "ja," for yes. The elders blindly chose one, and if it was "ja," it was God's sanction to the marriage. Bishop Edmund Steinitz wrote in *The Moravian Manual, Containing an Account of the Moravian Church*:

*The fundamental principle underlying the employment of the lot, in the case of marriages, was a noble principle of devotedness to the service of Christ. The Brethren believed that the extension of His kingdom, through their agency, should not be hindered by any of the relations of this life, in accordance with what the Lord himself said, as recorded in Matthew XIX 29. They feared that early engagements would prevent young men from going forth, as messengers of the Gospel, to distant lands, or render a long abode in them irksome; they were, moreover, convinced that it was a matter of the utmost importance not only to enter the marriage state in the fear of God but also to secure partners in life who would, in the fullest sense, be helpmates to them while laboring in the Lord's vineyard. Therefore, they had faith in Him that He would condescend to give them such wives as they needed, and as would approve themselves worthy handmaids of His. Besides, owing to the peculiar regulations of the settlements, young men and women had very little social intercourse. In this way, the lot came into use for contracting marriages in the case of missionaries and ministers, and gradually of all the members of the Church. But it was not employed in the manner so often set forth by ignorant writers. Men and women were not indiscriminately coupled, without their knowledge, and contrary to their wishes. The mode was simply this: when a man wished to marry, he proposed a woman to the authorities of the Church, or, if he had no proposal to make, left it to them to suggest a woman. The authorities submitted the proposal to the decision of the lot, and if it was sanctioned, made the woman an offer of marriage, in the name of the man, which offer she was at perfect liberty to reject, if she thought proper; for the lot bound the authorities to make the offer, but not the woman to accept it. If she refused, or if the proposal was negative by the lot, the man made another, and the authorities never forced any woman upon him against his will.*

*So far, therefore, from ridiculing this usage, an intelligent mind, capable of appreciating the spirit which animated the early Brethren in this respect, will be filled with profound admiration at the faith which they displayed. When confidence in this mode of contracting marriages began to wane, the rule was abrogated. But while it continued, there were fewer unhappy*

*marriages among the Brethren than among the same number of people in any other denominations of Christians. This is a well-known and abundantly substantiated fact.*[30]

Anna never mentioned her husband in her writings but wrote only of her love for Jesus and, sadly, the loss of her sons to the sinful world. The marriage record reads:

*WORBASS, Peter, b May 18, 1722 in Jutland, Denmark; carpenter; one of the few persons who escaped at the massacre in Gnadenhütten on the Mahoning; d 1806 in Nazareth.*
*SCHEML, Anna Maria, b Jan. 19, 1722; from Württemberg; d 1798 in Nazareth.*
*By Brother Graff, July 29, 1758.*[31]

Worbass's task was to get the new colony underway and in the pattern of the other settlements. The first industrial construction project was a mill. The families, however, lived in log cabins, and the foundation of the Worbass's cabin lies under the corner house on the main intersection of Route 519 and Route 521 in Hope. The Moravian ideal was to build a self-sustaining community, with profits shared by all. Unlike other communal societies, Moravian congregation members could own personal property. The first buildings included schools and common nurseries so that children could be supervised and educated while the mothers and fathers worked. A typical Moravian house, several of which have survived, was built of native limestone with the lime from the kilns, as it was in Stillwater, used for mortar between the stones. The mortar itself harvested from the kilns was buried in the fall to be used in the spring.[32] Most of these homes had a two-room first floor, with the fireplace going up the middle of the dwelling. There were two windows and a door in the front of the house, two windows in the back, a window at one end of the building and a door at the other. Fireplaces and ovens featuring cast-iron linings and grates heated much of the house. By 1773, additions of a tannery, a sawmill and a gristmill provided for almost all of the community's needs.

When most of the town was completed in May 1770, Christian Gregory, John Lorentz and Hans Christian von Schweinitz, members of the Moravian Provincial Helper's Conference, visited the new settlement and named it Greenland, in honor of the Green family. It was not considered a permanent settlement until 1774, when it was renamed Hope by the drawing of lots in

The Gemeinhaus in Mount Hope. *Courtesy of the Sussex County Historical Society.*

the Moravian fashion. It was then surveyed, and the "plans of the town were laid out."[33]

Less than twenty years later, the prosperity of this little town began to decline, although a sawmill and several new industries had been added. In 1793, a fire consumed the Gemeinhaus, which was one of the earliest structures used for worship and congregational meetings, as well as another building. By 1799, the population of the village fell from 147 to only 84. Another visit from the Provincial Helper's Conference revealed that eight of the houses had been abandoned and that the girls' school had been emptied. A new school was constructed, but it closed in under a year in favor of a fashionable boarding school in Bethlehem, today's Moravian College. The Single Sisters were also given a new residence at this time. Up to this year, the Moravian Diacony had owned the community store, which it sold to Daniel Kleist as sole proprietor. The Single Sisters Economy was abandoned. In 1807, visitors from the Unity's Elders Conference, which controlled Hope, visited and announced that the settlement would be dissolved and that the Moravian populace would be moved to other Moravian towns. Reasons suggested for the demise included the success of businesses owned by non-Moravians or the arrival of disease accompanied by deaths in number. The real reason was the condition of the supporting mother church in Europe, which could no longer support Hope due to poor financial conditions on the continent and the Napoleonic Wars. In 1808, the Moravian-owned

portion of the community was sold to various buyers, and the Moravian desire to create a "beautiful and thriving community in the wilderness" was not realized.

Hope, New Jersey, is the heartland of Warren County and one of the most beautiful historic villages in the state. Except for the fact that the old Gemeinhaus on the corner now sports a sign reading "Bank of Hope," everything appears the same as it was. Beautiful old stone houses line the streets and the farms in the adjoining areas. The hurricanes of 2012 and 2013 tore some of the trees down; however, the town survived, just as it did through the French and Indian, Revolutionary and Civil Wars.

# Chapter 4

# The Hessians

The Hessians are usually mentioned during the beginnings of a discussion of German immigration to America. The German soldier fighting for the British in the American Revolution was generically called a Hessian and is described as a cruel Teutonic mercenary who wore a "tin hat" over a wig and was captured by George Washington at the Battle of Trenton.

Andrew D. Mellick Jr. of New Germantown gave a speech entitled "The Hessians in New Jersey: Just a Little in Their Favor" at the New Jersey Historical Society in Trenton on January 24, 1888. Mellick was trying to remove some of the tarnish from the Hessian reputation:

> *Hessians! How they have been hated by the Jersey people! The very name is still spoken by many with a prolonged hiss. For generations, the word has been used even as a bug-a-boo with which to frighten children, and by the imperfectly read, the German troops have been stigmatized as "Dutch Robbers!" "Bloodthirsty Marauders!" and "Foreign Mercenaries!" Why blame these tools? While many of them were not saints, neither were they the miscreants and incendiaries bent on excursions of destruction and rapine that the traditions fostered by prejudiced historians would have us believe. Many of the Germans were kindly souls and probably the best-abused people of the time. Individually, they were not mercenaries, and a majority of the rank and file, without doubt, objected as strongly to being on American soil, fighting against liberty, as did their opposites to have them here.*[34]

Hessians and George Washington at the Battle of Trenton. *Courtesy of the Sussex County Historical Society.*

One thousand Hessian prisoners were brought from Trenton to Philadelphia on December 26, 1776. *Courtesy of the author.*

This image of a militaristic mercenary has been promoted through the years. For example, a silent movie starring Mary Pickford, the "queen of the silent films," called *The Hessian Renegades* was produced in 1909 by the Biograph Company in New York and directed by the pioneer D.W. Griffith. It portrays "the Hessian" (played by comedy genius Mack Sennett) as an

oafish, cruel man. The image is one-dimensional, but it has lingered for many years.

However, researchers have found that Hessians were a very different kind of soldier, purchased from various German princes for the modern equivalent of $150,000 in different towns in the eastern part of Germany. Hesse (hence the name) Cassel sent 16,992 soldiers to the "colonies," of which 6,500 did not return home. Hesse Hanau sent 2,422, and of these, 981 did not return. Of 5,723 Hessians sent from Brunswicks, 3,015 either died in battle or stayed behind. Anspach-Bayreuth shipped 2,553 men overseas, and of these, 1,178 did not return. Anhalt Zerbst provided 1,152 soldiers, of whom 168 did not return home. And Wladek responded with 1,225, and 720 of these stayed behind.[35] The treaty of February 12, 1776, between Landgrave Frederick II of Hesse Cassel and George III (his brother-in law) sent approximately 17,000 men to fight in America's Revolutionary War.

Many of these imported soldiers were conscripted. Some were paid soldiers, while others joined the army because they could not afford the passage fare to America and wished to join relatives there. Volunteers and the regular army made up the balance, and the officers were aristocrats who viewed warfare as a gentlemen's game. German soldiers had been regularly stationed in parts of England, including coast cities such as Weymouth, and were used to defend British outposts for "Cousin" King George in other parts of the world. For example, one troop, La Mott Division, was sent to Gibraltar to support British forces there, while others were committed after the proper money exchange to the colonies. Some of the "purchased" troops wrote of massive and violent conscription, which included roundups in churches, ill treatment and forced enlistments. One such account is Johann Gottfried Seume's autobiography, *Aus Meinem Leben*. Seume left Leipzig University after a theological conflict with his instructors, and as he traveled toward his home, he was waylaid and kidnapped into the Hessian army, headed for America. He had no choice and faced death, whippings, gauntlets and other forms of punishment if he did not comply. He wrote:

> *I left Leipzig after having paid my debts without saying anything to anybody. The second evening, I was in a village near Efurt, where I was well received and found cheap lodging. The third evening, I stayed in Vacha, and here the Landgrave of Kassel, the great trader in human beings of that day and age, took care, through his recruiting agents, of all of my future lodgings in Ziegenhahn, Kassel and later in the New World.*[36]

Seume describes two plots to escape (both thwarted) that resulted in terrible punishments. He landed in Canada and although he remained there as a military presence, he never fought in any battles. His voyage took twelve weeks, and he got some special privileges when the captain found him reading the poems of Horace on the deck of the ship. The voyage of these conscripted soldiers was uncomfortable to say the least. Seume wrote:

*On the English transporter, we were pressed and packed like salted herrings. To save room, the deck, low as it was, had been partitioned off, and we lay instead of in hammocks in these bunks, one row above the other. The deck was so low that a grown man could not stand upright, and the bunks were not high enough to sit in. These bunks were intended to hold six men each, but after four had entered, the remaining two could only find room by pressing in. The situation was, especially in warm weather, decidedly not cool: for one man to turn from one side to the other alone was absolutely impossible, and to lie on one's back was an equal impossibility. The straightest way and the hardest edge were necessary. After having roasted and sweated sufficiently on one side, the man who had the place to the extreme right would call, "Round about turn!" and all would simultaneously turn to the other side, then having received quantum satis on this one, the man to the left would give the same signal. The maintenance was on an equal scale. Today, bacon and peas—peas and bacon tomorrow. Once in a while, this menu was broken by porridge or peeled barley and, as an occasional great feast, by pudding. This pudding was made of musty flour, half salt and half sweet water and of very ancient mutton suet. The bacon could have been from four to five years old, was black at both outer edges, became yellow a little farther on and was white only in the very centre. The salted beef was in a very similar condition. The biscuits were often full of worms which we had to swallow in lieu of butter or dripping if we did not want to reduce our scanty rations still more. Besides this, they were so hard that we were forced to use cannonballs in breaking them into eatable pieces. Usually our hunger did not allow us to soak them, and often enough we had not the necessary water to do so. We were told (and not without some probability of truth) that these biscuits were French, and that the English, during the Seven Years' War had taken them from French ships. Since that time, they had been stored in some magazine in Portsmouth and were now being used to feed the Germans who were to kill the French under Rochambeau and Lafayette in America—if God so wotted. But apparently, God did not seem to fancy this idea much.*

Seume did return home; however, he had to buy his way out of the service in 1783 for an ostensible visit home, at which point he deserted. He became a poet and writer of some note and a colleague of composer Ludwig van Beethoven. Before he died, there was correspondence indicating that his poem "Die Beterin" (The Praying Woman) would be incorporated into the slow opening of "Moonlight Sonata." Although letters show Beethoven's agreement, nothing ever became of the project.

Claus Reuter, in an article written for the Canadian Museum of Applied History, disputed Seume's narrative, stating that it was concocted after the war to match "American propaganda and to sell books."[37] However, the truth is probably somewhere in between both accounts, although conscription, enlistment and kidnapping were known to be part of the process for raising troops.

Many of the Hessians who were captured or killed did not fare as well as Seume. Few records of the soldiers who remained in New Jersey and Philadelphia remain, and few American history textbooks deal in detail with Hessian troop movements. Even in the modern world, rumors of their desertions throughout New Jersey abound. Obviously, if they encountered a relative or friend in a town, they would consider deserting and hiding, under cover of a new name, in the town in which their contact lived. For example, in New Germantown, early settlers Lucas Dipple and John Appelman were from Hesse.

There were essentially three groups of Hessians that remained in New Jersey. The first was a group of one thousand German soldiers that had been captured during the Battle of Trenton. The second group, and perhaps the largest, was part of the Convention Army that marched from the Battle of Saratoga. On October 17, 1777, General John Burgoyne surrendered his army to General Horatio Gates following the October 7 Battle of Bemis Heights. The terms were that the soldiers were to be returned to Europe and paroled (unarmed) and that they would not fight again. The third group was composed of deserters who left when they found a relative or joined the Rebel army.

Desertion from the British army was encouraged by the colonials, and many deserted as a result of a proclamation, in German, from General Israel Putnam in November 1777, which stated that "the people of the United States were ready to receive the Germans as brothers and fellow inhabitants." They were also offered "as further encouragement" that if they wanted, "they would be carried back to the fatherland at public expense and would be paid for their regimental equipment according to its actual

worth." Some men deserted from prison camps in Lancaster, Pennsylvania, and Winchester, Virginia, as well as from Manhattan and Long Island. An estimated five thousand soldiers listed as Hessians left the British army. During the conflict, there was a severe labor shortage for the colonials, and Hessian prisoners were regularly used as laborers in local industries and on farms. Sometimes, the assignment of this captured labor force was not quite legal, in the sense that there was a sort of favor involved. However, the prisoners were used in the ironworks in Pennsylvania, in the construction of government buildings, as shoemakers and, most commonly, as farmhands.

One of the better known and best documented stories is that of John Jacob Faesch, the iron master of Morris County, New Jersey. Faesch made a trip to Philadelphia in April 1782 to negotiate his contract with the Continental army for the sale of shells. He desperately needed workers to add to the population of the Mount Hope Ironworks, which employed one to two hundred people, including women and children, who worked at the production of munitions for the military. He had lost many of his male workers to the army. The four shafts of the iron mines could provide two tons of shells per day. To produce one ton of iron, fourteen cords of wood had to be turned into charcoal. Faesch needed woodcutters and turned to the Hessian prisoners of war in Philadelphia. They had been badly treated on board prison ships, where a later letter states that they were fed no more than ten ounces of bread and the same quantity of meat or fish (fresh or salt) per day.[38] Often, they received ten ounces more of bread or fish in lieu of meat. And sometimes they were not allowed to purchase anything with their money.

From the prison, thirty-five men were chosen, primarily fusiliers from the von Knyphausen regiment. Captain Henry "Light Horse Harry" Lee, General Robert E. Lee's father, brought these men to Mount Hope, New Jersey (today's Rockaway Mall area). They were hired to cut wood for the forge and were to be paid three shillings and six pence a cord. For other work, they were paid four shillings and five pence per day in Pennsylvania money, from which Faesch deducted their victuals.[39] Although a local rumor places jail cells in the basement of the Faesch House (still standing), the prisoners were actually housed in log cabins, six men in each, which, with proper rations, made for comfortable living. Shortly after, an American captain (who happened to be German) came to the farm with eight or ten armed soldiers and demanded that the Hessians enlist in the Continental army or pay thirty pounds for the provisions issued to them during their imprisonment in Philadelphia, which the king's army had refused to pay,

or they would be returned to jail there. The story gets complicated here, because after an eight-day standoff, with Faesch unwilling to pay for their "parole," a judge was consulted, and it was agreed that since they did not want to join the enemy army, each man should be indentured to Mr. Faesch for three years to pay off their thirty pounds. Since their English was not very good, they thought that they would work for Faesch until the thirty pounds were paid off, but in actuality, the agreement called for their indenture for three years. They appealed to no avail to Lieutenant General von Lossberg in May 1783 and again in June for release from the indenture:

> *If the King will not pay the £30 for which we are kept in Slavery, and our Liberty cannot be obtained otherwise, we will buy it with the arrears of our pay and what little our parents at home may be able to give us. Let the money be paid for us. We will refund it all. We will do anything rather than abandon our country and everything dear to us in this world. Corporal Roeder will have told you all this. Mr. Faesch is going to New York in the course of the week to reclaim him or the money, which he has paid for him. Imagine the feelings of our poor disconsolate parents coming to meet you full of joy. When they search in vain for their children, whom they longed to press to their bosoms, when they were left in Slavery never to return—no tell them we will return. We will not forget our duty to them and our dear country. We will return as soon as we are free from our fetters.*[40]

One soldier, Private Valentin Landau, took the oath of allegiance to the United States and promised to pay an indenture for his freedom. The records of this transaction are located in the Dorchester, England Regimental Records[41] and indicate that thirty five men were delivered to Faesch for a labor force and that despite all the economic complications, by June 1783, Private Valentin Landau had purchased his freedom by indenturing himself to the mine owner. The British records remaining in England list that an agreement signed by B. Lincoln in Philadelphia on March 14, 1783, liberated Landau when he took the oath of allegiance to the colonial government in front of Abraham Mitchell. His indenture was to be for three years in consideration for the sum of eighty dollars to be paid for his liberation. There are later records of Landau being discharged for finishing his servitude, as well as a complaint by Landau that if he had repaid the £60 of lawful New Jersey money, he would not have been bound to serve.[42] There is irony in the fact that a prisoner had to pay off a captor who had purchased his service from someone else.

In July 1783, Major Carl Leopold Baumeister, von Lossberg's adjutant, traveled through southeastern Pennsylvania and found 345 German prisoners, of which few wanted to return home. By July of that year, he was in Mount Hope, where he found only twenty-seven of the original thirty-five prisoners. Eight had "escaped" to New York, and two had worked themselves free and settled in Philadelphia. No one scholar is certain about which German soldiers decided to stay behind and which went back to the homeland. Only seventeen of the Hessians remained on the company rolls after 1783. John Jacob Faesch became a prominent citizen in Morris County, eventually managing the Boonton Iron Works. He wrote to a cousin in Switzerland about how well the men in the Mount Hope camp felt that they were being treated. He claimed that after the hostilities were over, he personally introduced the Hessian officers to George Washington.[43]

There are, however, local legends about the fate of these Hessians. One soldier, Adolf Assmann, is listed as a deserter, and another, Leopold Zindle appears to have settled in the Mount Hope area. Longtime local residents, descendants of earlier settlers, tell stories of the Hessian soldiers changing their names (or at least changing the spelling) and joining relatives or of hiding their weapons in the walls of their newly constructed homes. Obviously, some were hiding in the Mount Hope/Morristown area, while others went on to New York or Philadelphia.[44]

In his story of Stillwater, Caspar Schaeffer mentions the settlement of a dozen or more Hessians who deserted from a detachment of Burgoyne's captured army on their way through Sussex to a location assigned to them as a place of safety near Charlottesville, Virginia. All those Germans settled and raised families in the neighborhood.[45] Local historians had heard of Hessians hiding in German communities from tales passed down over several generations, but no one is aware of how the soldiers got there. What is known is that Sussex County men were involved in the American Revolution. George Washington camped near what is today Wallkill Valley High School and marched down the King's Highway (present-day Route 94) in Hardyston. However, what is not as well known is the fact that this same route was used in part by the Convention Army, which was composed of soldiers of the British army (including Hessians) that had surrendered with General Burgoyne to General Gates at Saratoga on October 14, 1777.

There were thirteen articles in the Convention of Saratoga agreement, so named because the British commanders rejected "capitulation" or any other term indicating surrender. The very first articles stated the overall plan:

*I. The troops, under Lieutenant-General Burgoyne, to march out of their camp with the honors of war and the artillery of the entrenchments, to the verge of the river where the old fort stood, where the arms and artillery are to be left; the arms to be piled by word of command from their own officers.*

*II. A free passage to be granted to the army, under Lieutenant-General Burgoyne, to Great Britain, on condition of not serving again in North America during the present contest; and the port of Boston is assigned for the entry of transports to receive the troops whenever the General shall so order.*[46]

At the point of the surrender, the concept appeared to be a simple one: the defeated troops were to be marched to Boston, where they would then be quartered with provisions provided by General Gates until they could be shipped out. Officers were to be allowed to keep their carriages, "bat-horses" and cattle and of course expected to be treated as gentlemen. Canadian soldiers would be allowed to return home, never to serve in America again. In concept, the gentlemanly parole of prisoners sounds honorable—however, it ran afoul.

The exodus of German soldiers from the armies started here. The British general "Gentleman Johnny" Burgoyne arrived in Quebec on May 6, 1777. The troops he was to command had lived through a mild winter and were in good condition. According to the British records, 3,724 rank-and-file soldiers were in the unit with 3,016 Germans. The balance of the force contained 9,953 men. These figures are really estimates, since each side counted soldiers differently. However, probably 5,800 were captured, of which 2,198 were "foreigners," or German. If the Brunswick records are to be believed, the soldiers that arrived in America from Braunschweig (Brunswick) numbered nearly 5,700. However, only 2,700 returned home in 1783. Nearly 1,000 died or were killed, and there were also those who stayed, of which 700 settled in Canada and about 1,300 in the United States scattered from Maine to Virginia.[47]

The idea of returning soldiers to their homeland never happened as planned. The units stayed near Boston for over a year, facing monetary issues and rejection by the locale populace. The gentry, however, lived well. Finally, after much correspondence among the officers in charge, General Washington decided that sending the remaining troops home would not guarantee more in return; therefore, he planned, along with others, to march the parolees to Virginia. They set out on a five-hundred-mile march (with stops and turmoil on the way) to Charlottesville. The Convention

Army reached New Jersey, although the details and dates are unclear. The Hessian Brunswick troops marched through, deserting as they marched. Some joined the American army, while others simply joined their *landsmänner* (countrymen) in the farms and countryside. They were a ragtag bunch. A description of the Hessian surrender at Saratoga by John Becker, a young observer, presents a very different image of them. At the initial surrender, the British units turned in their weaponry first and were splendidly followed by their "very elegant officers." The German troops were, according to Becker, of another kind:

*The Hessians came lumbering in the rear. When were they ever in advance? Indeed their equipments prevented such an anomaly. Their heavy caps were almost equal to the weight of the whole equipment of a light infantry soldier. I looked at these men with commiseration. It was well known that their services had been sold by their own petty princes, that they were all collected together, if not caught at their churches while attending religious worship, and if we may credit the account given us, they were actually torn from their homes and handed over to the British government at so much a head to be transported across the ocean and wage war against a people of whose history and even of whose existence they were ignorant. They were found unfit for the business they were engaged in. They were unable to march through the woods and encounter the difficulties incident to movements in our most unsettled country. Many of them deserted to our army before and after the convention of Saratoga. Fifty have been known to come over in one party before the surrender.*

*A very remarkable disease prevailed among them, if the accounts of some respectable officers attached to Burgoyne's army may be credited. While on their way down from Canada, a presentiment would take possession of twenty or thirty at a time that they were going to die, and that they would never again see their fatherland. The impression could not be effaced from their minds, notwithstanding every exertion of their officers and the administering of medical remedies. A perfect maladie du pays, a homesickness of the fatal kind, oppressed their spirits and destroyed their health; and a large number actually died of this disorder of the heart. This is a fact too well established to be denied, and equals anything I ever heard related of the Swiss. Among the Germans that now passed before me were the Hesse Hanau regiment, Riedesel's dragoons, and Specht's regiment, the most remarkable of the whole. The officers of distinction who accompanied them were Major General Riedesel, Quartermaster General Gerlach,*

*Adjutant General Poelnitz, Secretary Langemegen, Brigadier General Gall and some others. The Hessians were extremely dirty in their persons and had a collection of wild animals in their train—the only thing American they had captured. Here you saw an artilleryman leading a black grizzly bear, who every now and then would rear upon his hind legs as if he were tired of going on all fours, or occasionally growl his disapprobation at being pulled along by his chain. In the same manner, a tamed deer would be seen tripping lightly after a grenadier. Young foxes were also observed looking. The troops were looking sagaciously at the spectators from the top of a baggage wagon, or a young raccoon securely clutched under the arm of a sharpshooter. There were a good many women accompanying the Germans, and what a miserable looking set of oddly dressed Gipsey [sic] featured females they were.*[48]

While their fate was being decided, correspondence between the minister of the Duke of Brunswick to the English suggested that those Germans who surrendered might not be allowed to return to their homeland lest they should be discontented and discourage others from enlisting. He said that they should be put on "one of your islands in America" or kept in British Territory in Europe.[49]

The journey of these troops, although documented in dairies and letters, contains little of the trip through New Jersey from Sussex to Sussex Court House (Newton) (via Route 94), Hackettstown (via Route 519 and 517), German Valley on to Frenchtown (via Route 513) and, finally, Philadelphia. The route they followed in New Jersey follows the course of roads on a Hessian Map of 1779 that shows Caspar Shaver's house in Stillwater as a stopping point.[50]

Boot of a Hessian officer who was taken prisoner at Saratoga in 1775. *Courtesy of the author.*

This army had been mistreated and was hungry, and when some of the soldiers saw countrymen along the wayside in Newton, Stillwater, German Valley and New Germantown, they left their ranks. The German divisions were, as best can be ascertained, First Division, dragoons, grenadiers and regiment of Rhetz; Second Division, regiments of Riesedel and Sprecht; Third Division, light infantry and artillery of Hesse Hanau. Since this march was not made on the honor of the regiments, Colonel Jacob Gerrish and the Cambridge Regiment Guards accompanied them. Each German division was to be kept separate by delaying each unit's march by one day; therefore, the troops were stretched out over a long distance. Bringing up the rear of this long column were the von Riesedels: the general, his wife and their four children, including a baby in arms. The opportunities for escape were evident, even though early on in the march three men had been sentenced to hang in Goshen, New York, for helping prisoners escape to New York City.[51]

Descriptions of this exodus usually include a very negative impression of the passing travelers; however, the observers were really a part of the enemy, who even with the accounts of dirty soldiers, smoking constantly and urinating in the streets, showed them no animosity.[52] They were ill clad, as their baggage had never been sent from Canada. There is an old story

The Hessian House in Stillwater, New Jersey. *Courtesy of the author.*

passed down from the farmers in Allamuchy Township that the passing troops were asked not to burn pastureland fences and that the request was honored. The sympathy offered to "prisoners" by their German compatriots would also indicate many more refuges found in New York, New Jersey and Pennsylvania. Not much of an effort was made to recapture deserters; however, because of the danger—real or imagined—many of the escapees changed or Anglicized their names. There is evidence of their settlements left behind over the years, including a Hessian House in Stillwater, a Hessian Pond in Sussex County, a Hessian Road in Montgomery and Belle Mead New Jersey; a Hessian Drive in Williamstown and a Hessian Run Park in Woodbury. The stories, legends and the Hessians themselves left their mark on New Jersey.

# Chapter 5

# Nineteenth-Century Migrations

After the American Revolution, the new country was expanding, and more Germans immigrated to work on farms and to build new ones. Meanwhile, in Europe, Napoleon was creating havoc among the German states, and there was a migration from area to area in the country itself. Anti-French sentiments reappeared, and the loosely formed German federation of thirty-nine states could do little about the actions of the "Little Corporal." The unrest on the continent spurred on immigration.

Early nineteenth-century Germany was also experiencing a revolutionary upheaval. The American and French revolutions had inspired a quest for freedom and self-government. During the middle part of the century, a strong Prussian ruler dissolved his parliament and caused what came to be known as the Revolution of 1848. Droves of German "48ers" or "Free Thinkers" sailed across the Atlantic to a new country. The onset of the American Civil War drew German soldiers to America. The Franco Prussian War of 1870, which eventually unified Germany, brought the onset of required compulsory military service and sent even more people to the United Sates.

## THE REVOLUTION OF 1848: THE 48ERS

The German Revolution of March 13, 1848, complicated national history because of the divided nation and questionable political action on the part

of the leaders. However, the national unrest caused immigrants to flood into American ports. Germans streamed into a new country. Some joined the army, while others found relatives and trades. This influx brought merchants and artisans enticed by the industrial growth in the new country, and German-speaking workers and their families filled the larger towns. The nonviolent revolutionaries were called "free thinkers" and promoted political

German immigrants in the late nineteenth century. *Courtesy of the Sussex County Historical Society.*

and philosophical ideas in the struggle for constitutional and equal rights for all. Artists and scholars were attracted to the freedom the United States had to offer. In 1850, a young artist in Düsseldorf, Emanuel Leutze (1816–1868), president of the Düsseldorf Artists Association, was obsessed with America and wished to encourage German liberalism and the revolution. While he lived in Düsseldorf, he created an inspirational painting of the American Revolution entitled *Washington Crossing the Delaware*, using the shores of the German town as the setting. This famous piece is hanging in the Metropolitan

The view of Düsseldorf from across the Rhine used by Leutze. *Courtesy of the author.*

*Washington Crossing the Delaware*, by Emanuel Leutze. *Wikimedia.*

Museum of Art in New York City and portrays Washington standing up in the boat approaching the shore of the river on Christmas 1776. For many years, the image has been criticized as historically incorrect because of the stance of the general in the boat. However, few people know that in the painting, Washington is actually crossing the Rhine.

The Kaiser, after promising libertarian rights and then curtailing them, ordered the military to fire into a protesting crowd in Berlin. After this event, a Prussian National Assembly was formed with the intent of uniting Germany. With the agreement of the Crown, a constitution was drafted but which suddenly shifted to a monarchial supported document, and the parliament was abruptly dissolved. The convoluted political, revolution and intellectual turmoil caused many men to be put in prison and many more to leave. Freedom of speech against the monarchy was curtailed, and many a journalist, author and publisher ran from the police, leaving the country through Switzerland and then heading on to America. Young Carl Schurz of Bonn, who helped an imprisoned friend to escape, was one of those that had to leave. Once in America, he developed a friendship and close association with Abraham Lincoln and became the titular leader of the German free thinkers. "I came mit Schurz" was the catchphrase of the 48ers, who came from all parts of Germany into New Jersey cities such as Hoboken (New Bremen, a major port of debarkation), Newark, Jersey City, Paterson, Passaic and Trenton, bringing with them the traditions, trades and foods from their homeland.

# Urban Growth: Newark

New Jersey's German American population had expanded tenfold since the American Revolution. In Newark, tanners, brewers, newspapermen and other industrial immigrants increased the city population from 6 Germans in 1830 to 136,608 by the mid-century. The pioneer of the brewing industry was a man named Stahl, who made the first "genuine lager beer" in the old Franklin Factory on High Street. John Nepomic Schalk, a native of Mösskirch in Baden, started the first lager brewing company in the United States on the corner of Napoleon Street and Hamburg Place, but the need for grain to supply the World War I armed forces caused the closure of the plant.[53]

Newark grew into a city with a definite ethnic flavor—many community leaders had emigrated from Germany during the revolution. The Reverend Frederick August Lehlbach had fled Ladenburg, Baden, where he had been sentenced to fifteen years of solitary confinement for being a member of a Constitutional Assembly, which crumbled after the failed revolution. In Newark, he became pastor of the Mulberry Street Evangelical Church and helped establish a German school and a German hospital on Green Street.[54]

Conrad Hollinger was a compatriot from Baden who had been arrested for political writings and was sentenced to one hundred years in jail. After being "liberated," he ran to Switzerland, a path that many of the 48ers took, landing in Newark, where he founded two German newspapers: *Der Nachbar* (The Neighbor) and the *New Jersey Volksmann* (New Jersey Peoples Paper).

Major Franz Umbscheiden was an outspoken German revolutionary from Bavaria who was captured and sentenced to death after several minor skirmishes under the command of General Franz Sigel in Baden. He escaped to Switzerland and then to the United States. In Newark, he became the city editor of the *New Yorker Staats-Zeitung* (New York State Newspaper) and, eventually, the *Volksmann*. Dr. Louis Greiner had also been imprisoned for his political stance at the University of Munich and for trying to establish a Republican government in Bavaria. Friends broke him out of prison, and he eventually arrived in Newark, where he became a prominent lawyer along with compatriot Charles T. Ziegler, who had followed the same path. (See Appendix for prominent Newark 48ers.)

These educated and urbane people, who contributed to the cultural life of a growing city, particularly in the area of music, formed one of the earliest singing societies in the country, the Eintracht Männergesang Verein, which gave its first concert on November 11, 1847. About forty years later, Gottfried Krueger built a large music hall on Belmont Avenue in the heart of the German District called Sänger Hall. The tradition of German choral societies lives into the modern era, with many of the current New Jersey societies having their roots in this period.

There were six Lutheran churches established between 1833 and 1889—five of them were German. The Grace English Lutheran Church had to have the reference to language in its name to distinguish ethnicity. Social and athletic clubs were also established during this period as the Germans moved onto Springfield Avenue and into the Ironbound section of Newark.

Other cities located near the ports began to absorb German immigrants during the same period. Some of them flocked to Hudson County, as a thriving German community began to develop there. The German language was being taught in the public schools, and German newspapers were published there as well. The Jersey City Heights/Hoboken area became an ethnic center. For the most part, these expatriates had money and educations and were able to settle in other cities as well, including Passaic, Paterson, Linden, Elizabeth, Trenton and Camden.

# The American Civil War

Transplanted Germans were very patriotic, and they quickly adopted the flag and customs of their new land. At the onset of the Civil War in 1860 and the initial call to arms, German men stepped up to the enlistment table and offered to serve. Many of them were decidedly abolitionist and found all forms of slavery abhorrent. When the call went out for additional troops, more men enlisted until nearly 500,000 German Americans had signed on to fight in the war. About half of them were immigrants who barely spoke any English and died on the battlefield without ever learning the language. Ethnic military companies became part of the New Jersey regiments. For example, the Third New Jersey Cavalry had three companies commanded by twelve German-born "barons." Their recruitment remains a mystery, although the government was paying large bounties for men with military experience. Did they hear of these monies in Germany? Did they come to America because of their "revolution" and simply sign up for the bounty? There were twenty-six men who listed their occupation as "soldier" on their muster roll. The German population of the army was large enough to cause the appointment of Franz Sigel, a German-speaking general, and of Major General Carl Schurz to serve under him.

In Marion, Alabama, Prussian artist Nicola Marschall designed the first flag of the Confederacy, as well as its uniform, and served as an officer in the Southern army along with 2,500 Germans. Many of the German Americans in the South, primarily from Virginia, moved into the industrial areas of the North at the end of the war.

# THE FRANCO-PRUSSIAN WAR OF 1870

The Franco-Prussian War (July 1870–May 1871) was not considered an "important" war in the world arena, but it resulted in the unification of German states into one industrial power and set the stage for twentieth-century conflicts. In this war, the Second French Empire was fighting the Kingdom of Prussia, the North German Confederation and the South German states of Baden, Wurttemberg and Bavaria as a result of the years of tension amongst the parties involved. Emperor Napoleon I had marched through Prussia on his ill-fated invasion of Russia. After continued strife in the Palatine region from the previous century, the monarchies were in apparent control of government. When Isabella II was removed from the Spanish throne in 1868, a Hohenzollern candidate was proposed. The issue came to a head when Otto von Bismarck, the "Iron Duke" and prime minister of Germany, released a telegram (dubbed the "Ems Telegram") sent to him by Wilhelm I that had been altered for the press to suggest that the French had insulted the Kaiser. As Bismarck had anticipated, Napoleon III declared war on Prussia within two days after the telegram had been published in the newspaper.

The war's outcome, with the crowning of Wilhelm as the Kaiser of the newly consolidated German Empire along with the Peace Treaty of 1871, which humiliated the French and gave 5 billion francs and Alsace Lorraine to the Germans, set the stage for the next century's two wars. The French

North German Lloyd Terminal in Hoboken, New Jersey. *Library of Congress.*

used the resulting animosity toward Imperial Germany as its empire rapidly expanded and grew to a population of 39 million. Princess Victoria of Great Britain had married the Kaiser's son, which cemented German-English relations for a time and sandwiched France between the two powers.

In former German states, a fear of "over-Prussianization" of the newly unified country was coupled with a style of military conscription viewed as strictly Prussian. Once the country was united, 100,000 twenty-year-old men were drafted and compelled to serve for twelve years—the first three years in a regular regiment, the next four in the reserve and the final five in the *Landwehr*, or militia. The other fear was of the *Kulturkampf* (culture struggle) promulgated by Prime Minister Otto von Bismarck. This time, the attack was on the German Catholic minority, resulting in the expulsion of many Catholic orders and the hysteria of anti-Jesuit and anti-monastic sentiments. Although Bismarck's idea failed and energized the Catholics into the Centre Party, many of them left the country along with Jews from the former Polish region. At the same time, anti-Semitic sentiment was fading, and Jews began assimilating and marrying into the upper echelons of German society, although they were still not allowed to hold office or be officers in the army.[55]

During this period, 723,000 Germans immigrated to the United States and settled primarily in the cities. The Ashkenazi German Jews came to Newark and New York, while the Catholics and Lutherans went to cities across the nation. As it had been previously, the motivation behind the immigration was to find a better life and earn a better living.

# Chapter 6

# Twentieth-Century Arrivals

At the beginning of the twentieth century, war was again imminent, and Germans again left their country to find jobs in America. Their compatriots who had left earlier used the German media to write glowingly of their new country. Many of the expatriated were holding positions in industry, trade and even government. The German newspapers were numerous, and the language was now being taught in the schools.

Because of the value placed by German Americans on education, their mark was left on American school systems. Kindergarten (child's garden) was introduced in 1855 in the Midwest, and physical, vocational and music education and gymnasiums were added in schools. The traditional old-country pursuits of Sunday family recreation began to take the place of stodgy, puritanical Sundays.

Life in America was very appealing to relatives left behind in the Old Country. The 1905 World's Fair, in St. Louis, invited German young people to "Come to America." German visitors who liked what they saw returned shortly thereafter to settle. These early-century years were, however, the end of the Golden Age in America, when everything was well and good in the world. Everything would change with the onset of World War I.

A portrait of the Körber family, circa 1895, before immigration. *Courtesy of Sandra Knowle.*

# WORLD WAR I

As the century progressed, trouble began brewing in Europe. The Kaiser of Imperial Germany, although part British, had been given a strict Teutonic upbringing. He had a withered and useless left arm from birth and permanent psychological damage caused by an abusive tutor. The Kaiser became the poster boy for the evil Hun in the Western world. The causes and machinations of World War I, sometimes called the "Great War," are convoluted and complex. The Kaiser was not in control of the war operations, which were in place to save the Austro-Hungarian Empire, and a complicated series of alliances between the European powers caused a war that left millions of casualties. War fever ran high in all capitals of the world as the United States tried to remain neutral. There was increased pressure for the United States to join the Allied forces in Europe.

This was an age of "yellow journalism," as fantastic headlines using catch phrases promoted newspaper sales. The World War became the "Great War," the British soldier became a "Tommy," the American became a "Doughboy" and the German became the evil "Hun." After the Germans attacked the *Lusitania*, American forces, including many German Americans, were finally sent to the battlefields in France. Although the German government claimed that the ship was carrying munitions and that its attack was therefore justified, the world saw the event as an act of overt aggression against innocent passengers. It was only in 2008 that divers discovered

World War I poster—"The Hun Is Still Watching!" *Library of Congress.*

that the *Lusitania* was not an innocent passenger ship but that it was indeed carrying munitions bound for Britain to be used against the Germans.[56] The British press called for reprisals to the "Pirate Hun," who had "slaughtered innocent civilians" aboard the ship. America entered the conflict and for the first time was at war on foreign soil. Many of the veterans of this conflict returned home with visible defects produced by combat wounds, including the inhalation of poison gas. For the first time in the century, Americans were getting a first-hand look at the effects of war.

After Germany's surrender in 1918, President Woodrow Wilson created a fourteen-point plan that he believed would produce a stable Europe. He presented this plan at a conference that included Lloyd George of England, Orlando of Italy and Clemenceau of France at Versailles. The plan called for:

Open Diplomacy: There should be no secret treaties between powers.

Freedom of Navigation: Seas should be free in both peace and war.

Free Trade: The barriers to trade between countries, such as custom duties, should be removed.

Multilateral Disarmament: All countries should reduce their armed forces to the lowest possible levels.

Colonies: People in European "owned" colonies should have a say in their future.

Russia: Russia should be allowed to operate whatever government it wanted, and that government should be accepted, supported and welcomed.

Belgium: Belgium should be evacuated and restored to its situation before the war.

France: France should have Alsace-Lorraine and any lands taken away during the war restored.

Italy: The Italian border should be readjusted according to nationality.

National Self-Determination: The national groups in Europe should, wherever possible, be given their independence.

Romania, Montenegro and Serbia: These countries should be evacuated, and Serbia should have an outlet to the sea.

Turkey: The people of Turkey should have a say in their future.

Poland: Poland should become an independent state with an outlet to the sea.

League of Nations: An assembly of all nations should be formed to protect world peace in the future.

Wilson's plan was not summarily rejected but was instead reworked so that the French government, which wanted Germany to be punished severely, would be satisfied. Although British Prime Minister Lloyd George agreed

with Wilson privately, he publicly sided with the French to save his office in the upcoming election. As a result, there were 440 clauses in the final treaty, the first 28 dealing with formation of the League of Nations and the remaining 414 dedicated to Germany's punishment. These included:

War Guilt Clause: Germany is to accept all blame for starting the war.
Financial Clauses: Germany is to repay for the damage caused by the war (£6,600 million /$33 billion).
Army: German army to be reduced to 100,000 men—no tanks.
Navy: German navy allowed only six ships and and no submarines. (The entire German navy of World War I lies beneath the waters of Scara Brae in Scotland.)
Air force: Not allowed.
Anschluss: Not allowed to unify with Austria.
Land: Germany lost Alsace Lorraine to France, Eupen and Malmedy to Belgium, North Schleswig to Denmark Some and some land to Poland and Czechoslovakia. The League of Nations took control of Germany's colonies.[57]

These penalties, which Germany had no choice but to accept, coupled with the high casualty count produced a future that proved disastrous. As the postwar years dragged on from 1918 to 1922, political changes within the country and extreme economic conditions forced a severe depression. Thousands of Germans were jobless and hungry. Food supplies were exhausted, and the country was placed on a severe rationing system. People tried to journey to the neighboring farms to buy food directly; however, legislation was enacted to make these purchases illegal. In Stuttgart, one nurse tried to bring milk from a nearby farm to her small nephews and nieces, hiding it under her cape. When stopped by the police, she poured the milk out on the railroad tracks rather than let them sell it on the black market. Children in that region were eating turnips, the only available food, for three meals a day. Bread, when available, was legally baked with sawdust as "filler," and coffee, a German staple, was made from field chicory weeds. One North German family connected to a wealthy "gentleman farmer" had their goods delivered to them by a hired hand who walked the seventy-five kilometers (forty-six miles) to their home. War veterans and widows changed from heroes to outcasts in the eyes of a hungry public, and politicians spoke up about the cost of supporting these people. Military pensions were severely cut to 50 percent of the original amount for widows and 30 percent for children. Veterans, unable to work, had their pensions reduced substantially.

The conditions in depressed postwar Germany fueled a massive immigration of Germans to the United States, as well as general unrest in the home country. 1,073,700 men were killed, and another 4,216,500 were wounded, affecting 64 percent of the German military. The wounded and lame returned home, but by 1922, they were no longer welcome. There were no jobs, and the Deutsche Mark was devalued to the point where 10,000 DM in the bank on a Friday was worth only 1 DM the following Monday.

German immigrants with relatives in the United States flowed into the ports of New Jersey, and many of them settled with relatives in Newark, Jersey City, Paterson, Trenton, Hoboken and Camden. Each immigrant had to have a sponsor in order to prove economic stability. Unfortunately, they were coming at the start of the Great Depression, and they were resented for taking jobs from native-born Americans.

Although they now had food, the immigrant children suffered the most. Their foreign tongue marked them in schools, and they were often ostracized as they tried to learn a difficult new language. Many never lost their German accent and were marked for life as the despicable enemy. The newcomers were placed in lower grades that were not age appropriate and as a result often dropped out school. When one little seven-year-old asked in his broken English to go to the restroom, his teacher replied, "Cross your legs, you damned Hun." His eldest sister left school rather than suffer a fifth-grade class at age fourteen.

For the younger women, men and war widows, immigration became an escape from the depression and hopelessness of a defeated homeland. Finding a relative to sponsor was easy, but finding a job was not; therefore, many of them took menial and domestic positions to learn the new language and make a living.

Most of the stories about leaving home for a strange land are very much the same. Margarethe Körber was born in 1911 in Wurthfleth, North Germany, near the North Sea in the area of Bremerhaven and Brake. She grew up on a farm, and while going to school, she did farm and domestic work at home. She came from an area where a formal apron was worn to class and removed at home in exchange for wooden clogs to finish the day's barnyard chores. When her elder sister Anni left for America, Margarethe wrote:

> *Plans for the future began to form in my mind to follow my sister Anni to America. When I talked to my father about this, he became very sad; saying that it will be very hard for me to let you go, but there is really nothing for you to look forward to here. Inflation was rampant; the market out of*

*control; money was printed with big numbers but bought very little. Father did not have the money to pay for my trip across the ocean. Now, plans had to be made. Who is going to sponsor me for the entrance into the U.S.A.? Second, who is going to advance me the money for the trip?*[58]

Friends of the family lent her the money; however, the journey for a young immigrant in these years had hardly begun. Margarethe wrote:

*The American Consul had to be notified of my intentions. My name was put in the immigration list [quota]. Next, a passport [had] to be acquired; physical examination by an American Doctor, and after that, just waiting to be called. When that happened, I chose the ocean liner München to depart from Bremerhaven on February 29, 1929.*[59]

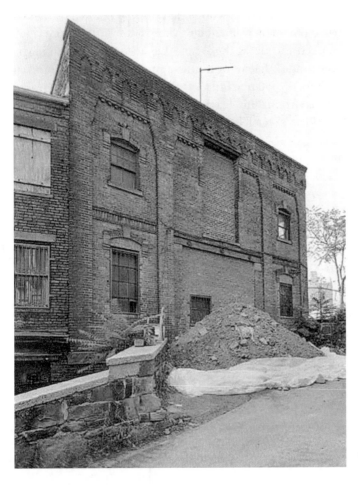

Ballantine Brewery, Newark, New Jersey. *Library of Congress.*

Margarethe went to Jamaica, Queens, where her family's friends helped her look for a job. She was lucky to find work as a domestic with a Jewish family for $40 a month, which she used to pay back the loan to her friends for her $350 fare. She remained terribly lonely and homesick during her first year. Although she was treated kindly, Margarethe changed jobs in 1932. She got married in the mid-1930s, and she and her husband moved to New Jersey, opened a delicatessen and raised a family.

These hardy immigrants found work anywhere they could. The industrious German temperament surfaced, and soon workers were filling factory and manufacturing jobs in places such as the Becton Dickinson thermometer plant in East Rutherford and the Guenther silk mills in Dover. There was also work in German breweries in Newark and food-manufacturing plants. Children became successful in New Jersey schools, as well as major colleges and universities across the country.

When the stock market crashed in 1929, immigration slowed down because of national unemployment, and Ellis Island was shut down. Employment in Germany became difficult as well. Political parties were raging battles with each other, each offering a solution to the country's depression. The 1917 Bolshevik Revolution in Russia sent many Eastern Europeans through Germany or to America. And some believe that the Treaty of Versailles, designed to punish unified Germany, led to the rise of the Nazis in World War II.

# World War II

After the Treaty of Versailles was signed at the end of World War I, the hope was that the "Hun," now brought to his knees, would simply go away. When German president Paul von Hindenburg died in 1934, Chancellor Adolph Hitler abolished the office of president and replaced the position with that of the Führer und Reichskanzler, naming himself as the virtual dictator and sole leader. Hitler was a wounded, decorated veteran of World War I who had risen to the rank of corporal. His gift of oratory allowed him, through propaganda, public tirades and emotional speeches, to generate an emotional reaction and support for the cause of the "restoration of Germany to its former glory." The depressed, hungry and downtrodden society was looking for a leader and financial relief.

German Americans in pre–World War II America were receiving letters from their homeland praising the new leader and promising a glorious future. Schoolchildren were being taken to the national festivals to see the new leader, and the tone of the letters to relatives in the United States was joyous, filled with praise and, at times, an open invitation to return to the homeland for a glorious future. For example, one schoolgirl wrote to her cousin in the United States:

> *On Saturday evening, and together with a few other teachers and students of our school, we took the train to Hamlin, arriving there at midnight. Then, at eight, we took the steamer to Bückeberg, where Hitler arrived at noon. You would hardly be able to imagine the enthusiasm of that crowd. There were one and a half million people. After the various speeches, there were military presentations of the different branches of service. The air attacks and the squadrons were probably the most exciting things I had ever seen. 1 Nov 1935.[60]*

At first, the German relatives stateside were thrilled with the resurgence of nationalism and a response to the destructive depression. Hitler's charismatic leadership masked the reality of the possibilities of war, and some Germans living in America returned to the fatherland. Others were vociferous in their support of Hitler as a savior and architect of new Germany. The schoolgirl who had visited Hamlin in 1935 traveled to Berlin to a mass rally and wrote to her cousin in the United States:

> *The festival of the 700th anniversary of the founding of Berlin will be repeated in the Olympic Stadium. And "Unter den Linden" has been beautifully decorated. I am including a photo of it, which of course can barely give the impression which the lighting produces to a person who is present. It is amazing! The teachers will not get to see me much; I will be mostly out and about. I so regretted that I could not go to Nürenberg. It must have been marvelous! Did you see the pictures or hear any of the speeches? The final speech of the Führer was simply inspiring. So, now you can imagine what it would be like to actually see him in the cheering crowd. It gives one a strange emotion—one feels like both laughing and crying. Next year, I will surely go to Nürenberg! We are also experiencing something unique in Berlin, namely [a practice run] blackout with bombing attacks. It started this morning. I was sleeping peacefully, but suddenly was wide-awake because of the wail of a siren, the sign of alarm meaning that*

*enemy planes are approaching. I jumped out of bed, put on my clothes and rushed to the air raid shelter! Soon after, we heard the enemy planes roaring above us, making an enormous racket. We even heard the rat-tat-tat-tat of the Flak. After half an hour, the alarm was over, and everyone went back to his or her place. In our case, we were perfectly normal, German Jews, one Japanese and two Romanians. Soon after, a whole squadron flew over our building—a wonderful sight which made one proud of our soldiers and of our power! I believe when the foreigners see all this, for example, the presentations of the Armed Forces in Nürenberg or the parade at Hitler's birthday, etc., they will get an inkling of German strength.*

*For six days, Berlin will be blacked out. A difficult situation for everyone. There will also be an alarm every night. You haven't had such an experience in New York yet, right? I would not like to live abroad. I have just read Roosevelt's speech which he gave in Washington; it really shows very little understanding of the German position, and strange ideas about the government of National Socialism. 20 Sept 1937.*[61]

In the 1930s, anti-Semitism in America was unspoken. Major universities used quota systems, admitting less-qualified Christian students over Jewish scholars. This discrimination in the United States was commonplace, and it masked the matching feelings from relatives in Germany, a country that had seen an integration of Jews into the mainstream of the culture by intermarriage prior to the Nazi Nuremberg Laws of 1935. Therefore, to many German Americans, Nazi anti-Semitism was a non-issue. However, that did not mean that the cause for restoration of the fatherland was ignored. The following was written by a New York man to his daughter, who was visiting in Germany during October 1934:

*Last Saturday night, we again had German Day at Madison Square Garden. This time, it was quieter than last year...there were maybe 20,000 people. It was quite late when I closed the business up and went there for five minutes. There I accidentally met Hermann in full uniform.*[62]

The most radical Germans in America returned to their homeland hoping to become part of a glorious future and a newly restored country. Others stayed loyal politically, and their vociferous support often led them to "Bund" meetings, which did nothing but encourage anti-German feelings before the war started. On the other side of the ocean, however, many Germans decided to leave their home country, finding Hitler's policies and reforms repugnant.

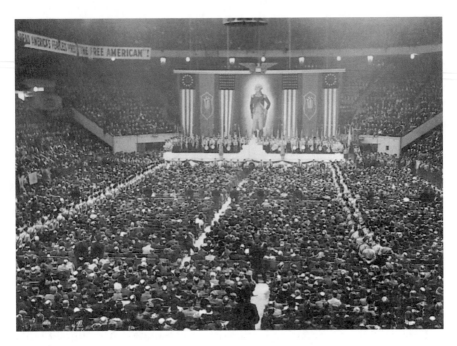

German Day, 1939, Madison Square Garden. *Library of Congress.*

This was in contrast to the majority, who found the policies of Hitler's National Socialist Party a relief from the years of war, hunger and economic despair. Some who believed in the party line eventually became disillusioned about the new policies but were unable to leave the country. Those who had wished to abandon the homeland made the choice to leave and sought out relatives and friends who would sponsor their entrance into America. The American Depression and the lack of employment, however, slowed down the immigration and forced many of the well-educated Germans to take factory and manufacturing jobs in New Jersey cities. One young retail executive who rejected Hitler youth left a job in a Stuttgart departmental store but upon arrival in New York found the position promised to him had vanished as the company had gone bankrupt. His only recourse was to find menial work in a cemetery digging graves and mowing lawns.

Many German Jews, anticipating the reality of death and isolation, were able flee before the war began. Motivated by patriotism for their new country, many German Americans already in America at the onset of the war signed up to join the United States services. Unfortunately, Germans already in Europe on a family visit or business trip were retained by the Nazis and forced into German military units.

The war fostered ugly repercussions in America for those of German, Italian and Japanese descent. These ethnic groups were viewed with suspicion during the war and with hatred after it. Postwar America was itself recovering from food rationing and unemployment. Europe was devastated, demolished and defeated. As late as the early 1960s, ruined buildings stood in mute testament to the repeated bombings. Millions of civilians were hungry and homeless. Refugees sought sanctuary in Germany, where there was a housing crisis. In Prussian Königsberg (Kalingrad), twelve million Germans, accompanied by many of the homeless from Poland and the Ukraine, were marched out by the Russians.

At the conclusion of the war, Germany was divided into four "occupied" zones governed in turn by the United States, France, Britain and the Soviet Union. Eventually, the supervisory areas became West and East Germany, with Berlin a part of the West Germany surrounded by the Russian-controlled east. The Russians wanted people from countries now under their control to return to their homeland, which many refugees were afraid to do. The number of "displaced persons" has never been recorded; however, the best estimate is 11 million. In 1948, President Truman signed a bill allowing 400,000 refugees to immigrate to the United States, even though he felt it was not enough. Most were German, Polish and Russian Jews who had survived the Holocaust. The American and British authorities placed a postwar ban on all humanitarian aid to German families. Churches and families trying to send food and aid to their relatives were not allowed to do so. When this ban was lifted and packages of food and clothing could be sent to cousins, uncles and aunts, the contents were restricted, and the fear of theft and the black market hovered over the donations. American mothers and fathers would wait until a letter from the "other side" reported that the food and clothing had safely arrived. The following letter was sent by woman in a small town in Southern Germany that had survived several bombings to her brother in New York City:

*Laufen, 25 May 1948*
*Meine Lieben!*

*Today, like lightening out of a clear blue sky, came your package; it only took 21 days. I was just standing at the kitchen counter, chewing a piece of black bread and wondering, "What will I make for supper?" And then the bell rings, I race to the door, and who is there but the mailman with the package. Oh, what happiness! Many, many heartfelt thanks. Everything*

*arrived in perfect condition and is so much help just now. The day after tomorrow, I will go to Stuttgart because Ruth is not coming this Sunday and she will be so happy when I bring her coffee and tea, sugar and peas. Then she won't have to cook for two days. For the last ten days, she has once again been at the end of her strength and has heart problems again, which is not surprising considering this heat. She had a cold, and it affected the pleura and gave her pain. I also still suffer from my head cold, but a cup of coffee or tea, which I am drinking right now, works wonders. My head was so fuzzy I thought I could not gather my thoughts at all, and I had a painful headache. But of course I cannot think of resting. It is one job after the other, and then the sickness goes away.*

*Many thanks for the Hansaplast* [bandages]. *I used almost the last of it on my battered knee; it served me well. And for the stockings, many thanks, dear Annemieze. Didn't you need them anymore? If I did not have your dried egg powder, I would often not know what to do. In any case, I can assure you that it has only been due to your energetic help that I have been able to carry on the way I have. The sugar I will save for making jam, as one cannot use brown sugar for that, and we are only getting that kind. At the moment, there are negotiations to decide if it would be possible to refine it for us* [the German population]. *I hope it will be permitted. The worst problem at the moment is milk. This is why I am so receptive to your dried milk. So often I would not otherwise know what to cook for Johanne. This way, I can at least make him some farina or rice with milk or pancakes. That is so wonderful. Our meat ration is 100 g per month. Enormous. That roast is invisible.*[63]

Letters like this one came to German American families when food was received. Those refugees, which included orphaned and helpless children, were not able to receive help from any outside sources. The Jewish victims of concentration camps, after being released from their years of torture and starvation, were able to find refuge only in large displaced person camps.

Toward the end of the war, in September 1944, a Volksturm (People's Army) was formed under the command of Heinrich Himmler. All men ages sixteen to sixty were drafted into this new army, but many of these "men" were actually boys under the age of sixteen. American troops reported that eight-year-olds were fighting at Aachen.[64] The only schooling these children knew was what was learned at Hitler Youth camps. Therefore, they were not educated or trained for jobs and were qualified only for low-paying menial work. One teacher was drafted during the early years of the war and placed,

because of his advanced education and against his wishes, into the SS (Schutzstaffel). He never worked again after the war. Every application was refused based on his war record. Men who had served in the Nazi military had a difficult time procuring jobs and often became homeless. Another man who had been a "boy soldier" drank himself to death after placing all his children in a Hamburg orphanage.

However, families and relatives in America, who had sad tales and memories of bombings, starvation and the violent or horrible deaths of their parents from World War I, adopted orphaned German children who were the "collateral damage of war." Their parents either were dead or had disappeared, and when the children became a financial burden, they were dropped into orphanages or, in worse cases, left to fend for themselves. This continued well into the late 1960s and the early '70s. Children in these institutions were not educated or fed well. They often had to resort to theft to get food for themselves and their brothers and sisters. If they were fortunate enough to have a connection with any relative, even tangentially, in the United States, they were allowed to be adopted and sent there. Some who went privately (not through an agency) to an adopted family had not been schooled, could not read or write and did not speak English. These were not babies; they were five-, six- and seven-year-olds who were then placed in the mainstream of suburban elementary education throughout New Jersey. Some overcame it quickly, while others were seen as difficult or stupid. Neighbors, teachers and classmates were not told that they did not speak English, and their Nazi Germany heritage was considered an embarrassment. These children, now grown and still living in New Jersey, have forgotten their native language and have had their original name changed to that of the adoptive family.

There is recorded material on the immigration of the German Jewish refugees who survived the Holocaust or who were able to leave during the war. American laws limited the numbers that came until the postwar period. The postwar Jews arrived in the same manner as the orphaned children had—attached to a friend or relative and settling in among the mainstream of local German Jewish communities, particularly Newark. They did not speak of their wartime experiences because they thought no one would believe them anyway. When the Holocaust memorials and stories became known, along with the release of the movie *Schindler's List*, the public became more aware of their presence. There are twenty-two Schindler streets in New Jersey today.

The new century brought further restrictions on European immigration, and fewer and fewer Germans reached America. However, the influx of

German-owned corporations in New Jersey brought communities of people to work for them. For the most part, over the course of three centuries, Germans and German Americans have come to New Jersey for different reasons and have served in the military and in civil service and have contributed inventions and industrial development to the Garden State.

# Chapter 7
# Discrimination and Hatred

## THE EIGHTEENTH CENTURY

All immigrant groups face negativity and prejudice from earlier settlers, and the German Americans were no different. Even though no longer permitted in the media, racial and ethnic stereotypes are now submerged in ads and commentary projecting persona of all the American ethnic groups. Negative and often prejudicial feelings toward German Americans have carried over into the twenty-first century, where they are viewed as dangerous, militaristic Nazis. The pop-culture image of the German American is stereotypically a stout, lederhosen-wearing, beer-drinking man who wears a funny hat with a big feather. The women wear low-cut Bavarian dirndls and carry six foaming beer steins in each hand. This picture appears in a wine commercial and ad with the tagline, "Get yourself a little German." In reality, ethnic dress and customs from other parts of Germany are different. Many German Americans feel that their negative image is a result of the Holocaust and Nazi Germany. However, the deep-rooted anti-Teutonic feelings go much further back in history than that. In 1751, Benjamin Franklin wrote the following in a letter to Caesar Rodney, a signer of the Declaration of Independence:

> *Those who come hither are generally of the most ignorant stupid sort of their own nation…and as few of the English understand the German language, and so cannot address them either from the press or pulpit, 'tis*

*almost impossible to remove any prejudices they once entertain. Not being used to Liberty, they know not how to make a modest use of it. I remember when they modestly declined intermeddling in our elections, but now they come in droves, and carry all before them, except in one or two counties. In short, unless the stream of their importation could be turned from this to other colonies, as you very judiciously propose, they will soon so outnumber us, that all the advantages we have will not, in my opinion, be able to preserve our language, and even our Government will become precarious.*

*Why should Pennsylvania, founded by the English, become a colony of aliens, who will shortly be so numerous as to Germanize us instead of our Anglifying them, and will never adopt our language or customs any more than they can acquire our complexion.*

*Which leads me to add one remark: that the number of purely white people in the World is proportionally very small. All Africa is black or tawny. Asia, chiefly tawny. America (exclusive of the newcomers), wholly so. And in Europe, the Spaniards, Italians, French, Russians and Swedes are generally of what we call a swarthy complexion; as are the Germans also, the Saxons only excepted, who with the English make the principal body of white people on the face of the earth.*[65]

# THE NINETEENTH CENTURY

After the Revolutionary War, the number of Germans in New Jersey was estimated as 20,000 of the total population of 184,139 people living in the state.[66] They were primarily Protestant, with communities of Bavarian Catholic immigrants in the larger regions. Anti-Catholic sentiment arose as more and more Germans came into the country during and after the Revolution of 1848, along with the Irish running from the Potato Famine between 1845 and 1852. An anti-Catholic, anti-immigrant party called the Know-Nothings started as a secret fraternity called the Order of the Star-Spangled Banner, and native-born Protestants were the only people qualified for membership. The "plank" of this party called for extending the naturalization period for citizens from five to twenty-one years and for banning all immigrants and Catholics from public office. If asked whether they were involved, members would say, "I know nothing"—hence the later name of the party.[67] By 1856, the party abandoned all secrecy and

campaigned publicly on a nativism ticket. It also split on the issue of slavery at its national convention in the same year. Northern Know-Nothings eventually joined the Republican Party and helped elect Abraham Lincoln in 1860.

The nativists fostered their own paramilitary units called the "Wide Awakes" to intimidate immigrants on election days indiscriminate of Protestant or Catholic convictions. They went on "paddy hunts" in many cities to attack immigrants. Usually, the Know-Nothings were connected to anti-Irish sentiment; however, other predominantly Catholic immigrant groups were also subject to violence and hatred. South Germans and Bavarians fell into this category. Humphrey Desmond, in his book *The Know-Nothing Party*, wrote:

> *There never was any deep-seated antipathy to foreigners as such in this country. Nativism in its restricted sense (dislike of European immigrants on account of their birth) was always more or less accidental and sporadic. It is usual in discussing the genesis of the Native American movements to refer to the Alien Acts of 1798 as one of the first manifestations of this feeling, or to the mythical order of Washington at Valley Forge: "Put none but Americans on guard tonight."*[68]

The nativists passed the following resolution at a meeting in New York City on June 10, 1843:

> *Resolved: That we as Americans will never consent to allow the government established by our Revolutionary forefathers to pass into the hands of foreigners, and that while we open the door to the oppressed of every nation and offer a home and an asylum, we reserve ourselves the right of administering the government in conformity with the principles laid down by those who have committed it to our care.*[69]

This political party arose just as the immigrants from Germany were arriving during the Revolution of 1848, and one could only help but wonder if the nativist riots in Philadelphia in 1842 influenced the movement of Germans away from there and New York City into New Jersey.

According to Albert Faust, and based on the U.S. census of 1900, at this time, there were 7,310,604 persons of German parentage in the United States.[70] The Know-Nothings claimed that they were primarily anti-Pope and therefore anti-Catholic; however, their tentacles of hate seemed to

spread quickly throughout all parts of the country. German farmers in New Jersey were spread apart in rural areas and were not subject to the abuse that was heaped on the "foreigners" who lived in the more crowded areas.

Abraham Lincoln, while running for president in 1860, was accused by the opposition of being a Know-Nothing as the Whig party dissolved. He wrote:

> *Our progress in degeneracy appears to me to be rapid. As a nation, we began by declaring, "All men are created equal." We now practically read it, "All men are created equal, except negroes." When the Know-Nothings get control, it will read, "All men are created equal, except negroes, and foreigners, and Catholics." When it comes to this, I should prefer emigrating to some country where they make no pretense of loving liberty—to Russia, for instance, where despotism can be taken pure and without the base alloy of hypocrisy.*[71]

At the onset of the Civil War, the majority of German Northerners opposed slavery. However, their presence in some of the German American units caused a problem for commanders since many German-born soldiers did not speak English. The old-line officers considered the German soldier a difficulty because of his clannish behavior and odd-sounding language. The solution was to assign them to all German-speaking companies and to keep them isolated from the other soldiers.

The unification of Germany into one country centered on Prussia, and the Franco-Prussian War sent many Germans into the established industrial world of a growing America. They left partly because of the May Laws of the 1870s, which were deliberately anti-Catholic edits fostered by the "Iron Duke," Otto von Bismarck. These *Maigesetze*, or Falk Laws, handed training and appointment of the clergy over to the state, which caused the closure of about half of the seminaries in Prussia. The Congregations Law of 1875 ended any state subsidies to the Catholic Church and made marriage a required civil ceremony. The *Kulturkampf* forged a wave of anti-Catholicism in Germany that created a backlash of sympathy and the construction of a Catholic Party. This *Kulturkampf* carried over to anti-Catholic feelings toward the Bavarian and Southern German Catholics in the larger cities of New Jersey. The clannish behavior of some of the immigrants helped to create German *Vereins*, or clubs, based on the inner Germanic cultural ethnic centers. These clubs sprang up all over New Jersey and, as with any foreign-based group, were viewed with suspicion by the "natives." Between 1880

and 1890, more than 1.4 million Germans arrived in the United States. These immigrants filled menial industrial jobs and caused further hatred and discrimination toward newcomers. The German immigrant population had increased by approximately 300,000 per decade by 1930.

# The Twentieth Century

## *Hating the Hun*

It is hard to enumerate German immigrants that came after the "Great War." Many of the war widows found that marriage to an American citizen brought instant American citizenship for herself and the entire family. In a courtroom at Ellis Island, there were lines of grooms waiting for their foreign brides. The influx of people from war-torn Europe brought resentment to the American people. Some called them "greeners," while others called them "the enemy" or "the Huns." They also suffered from American wartime propaganda aimed at supporting the war effort.

George Creel, the president's appointed head of American propaganda during World War I, sold the public on the image of Germans as "barbarous Huns." It was at this point that

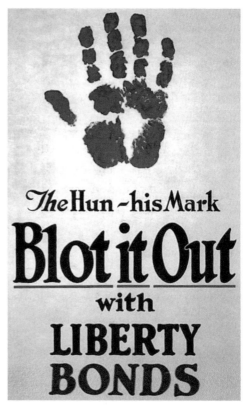

The Hun's mark—blot it out. *Library of Congress.*

the anti-Hun feeling was propelled to the fore in American propaganda on posters and at rallies in support of the American war effort.

The public had difficulty separating their German American neighbors from the "evil" across the water. The Great War was the first war in which information was broadcast by telegraph and radio. The kneejerk reaction to an unseen enemy, it appears, transferred the face of the enemy to friends and neighbors and caused many German Americans to change their own names, as well as the names of streets and food, to patriotically acceptable ones, safely obliterating the connection to the Hun. "Frankfurters" became "hot dogs," "hamburgers" were known as "meat patties" and "sauerkraut" became "victory cabbage." German Street in Dover was changed to Liberty Street. The Brauns became the Browns, while the Schmidts became the Smiths. Most German Americans remained silent in fear of ethnic backlash, and many anglicized their first names as well to fit in the New World. Johannes became John, Heinrich was now known as Henry and Heinz became Henry or Harry. German Americans believed they were in danger of being a suspected spy or "sympathizer" and therefore took measures to hide their ethnicity.

The Bryce Report of German atrocities in Belgium was released on May 12, 1915, in thirty languages across the globe. The German army was reportedly raping women, bayoneting babies, slaughtering hundreds and burning the houses of innocent people. To date, the controversy over the veracity of the report still lingers. Bryce never revealed the identity of his supposed eyewitness. The German became the face of the savage enemy and needed to face punishment and severe reparations.

## *Promoting Animosity: The Nazi Bund Camps in New Jersey*

Radical, pro-Nazi groups and other purveyors of hate in New Jersey found solace in Bund camps. The main gathering place was Camp Nordland in Andover, New Jersey, which in 1939 and 1940 often drew as many as eight thousand supporters to a training-camp environment run by the uniformed, self-styled American branch of the German Nazi party. Followers included some Italians and Polish, as well as American bigots. The Ku Klux Klan was attracted to these meetings and events and joined with a self-anointed "American Führer," Fritz Kuhn, who marched in full uniform while echoing Hitler's rants. He visited Germany for the 1936 Olympics and had his picture taken with Hitler. Upon his return to the states, he proclaimed himself a close friend of the German chancellor. He used the photo as

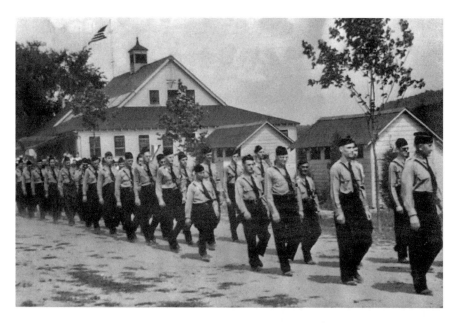

Bundists marching at Camp Nordland, Andover, New Jersey. *Courtesy of Wayne McCabe.*

Camp Nordland, Andover, New Jersey. *Courtesy of the Sussex County Historical Society.*

propaganda for his followers, who enjoyed the atmosphere, food and drink at the Bund camps.

Pre–World War II Americans, still suffering from the image of the barbaric Hun, hated this pompous, racist poseur. In Newark, a Jewish vigilante group headed by Longie Zwillman, a local Jewish mobster,

Fritz Kuhn thought he was the American Hitler. *Library of Congress.*

violently beat any stray Bund members or meeting goers when they encountered them. There were Bund meetings in Sänger Hall in Newark, and association with singing societies was used as cover for the fundraising pseudo-Nazi groups that evolved. The mobsters, whose violence was a product of earlier Prohibition years, took matters into their own hands, and rioting became a strong possibility.

People afraid of Nazi anti-American infiltration reported any and every supposed sympathizer to the FBI, which was actively recording suspects. These records included names, addresses, license plate numbers, telephone numbers and reasons for suspicion, including instances of German being spoken in the household. Interestingly, German American Jews, whose families were held in Nazi labor camps, became targets of suspicion as spies, fostered by the belief that the imprisoned relatives could be used by the

Nazis as hostages to blackmail the Americans into underground espionage. Many German-born immigrants were afraid to use their native tongue or to teach it to their children for fear of incarceration.

The U.S. Department of Justice oversaw the processing of the cases and the internment program. Although many were released or paroled after hearings before a local alien enemy hearing board, for some, the adversarial hearings resulted in internment that, in a few cases, lasted beyond the end of World War II. Of those interned, there was evidence that some had pro-Axis sympathies. Many others were interned based on weak evidence or unsubstantiated accusations of which they were never told or had little power to refute. Often, families, including naturalized or American-born spouses and children, of those interned voluntarily joined them in internment.[72]

By the end of the war, over thirty-one thousand suspected enemy aliens and their families, including a few Jewish refugees from Nazi Germany, had been interned at Immigration and Naturalization Services (INS) internment camps and military facilities throughout the United States. Some internment locations included Sharp Park Detention Station, California; Kooskia Interment Camp, Idaho; Fort Missoula Internment Camp, Montana; Fort Stanton Internment Camp and Santa Fe Internment Camp, New Mexico; Ellis Island Detention Station, New York; Fort Lincoln Internment Camp, North Dakota; Fort Forrest, Tennessee; and Crystal City Internment Camp, Kennedy Detention Station and Seagoville Detention Station in Texas.

Few Americans knew of the centers for retaining suspects whose rights had been withheld; however, Nazi loyalists flocked to the Bund camp in Andover, New Jersey. The FBI records show that members of the Ku Klux Klan and Italian Brownshirts were there as well. The major buildings of Camp Nordland are still there in Andover and are used as part of the town's recreation complex. The camp buildings where young Nazis stayed have been demolished; however, there are still scattered swastikas, deep in the woods, standing as crude, lasting monuments to hatred. These camps did nothing but promote anti-German feelings, which did not seem to bother its egotistical, pompous leadership. Local residents of Newton remember the youth groups marching in quick time and "goose stepping" through the center of town during summer camp excursions. In 1938, when Adolph Hitler clearly disassociated himself and his party from Kuhn for fear of American hatred of his government, the American party turned toward the other hate groups for support.

Most German Americans came to this country for the freedom it offered. Although some were definitely clannish and distrustful of other ethnic groups,

most were supportive of any minority that had suffered as they had. In 1942, famed journalist Dorothy Thompson and fifty other Americans of German descent, including Babe Ruth, took out a full-page ad in the *New York Times* for a "Christmas Declaration By Men and Women of German Ancestry":

> *We Americans of German descent raise our voices in denunciation of the Hitler policy of cold-blooded extermination of the Jews of Europe and against the barbarities committed by the Nazis against all other innocent peoples under their sway. These horrors are, in particular, a challenge to those who, like ourselves, are descendants of the Germany that once stood in the foremost ranks of civilization. We utterly repudiate every thought and deed of Hitler and his Nazis and urge Germany to overthrow a regime which is in the infamy of German history.*

The American Nazis, however, succeeded in attracting all the fringe lunatics who supported the cause of hate and racism. They masqueraded as "true Americans" under the guise of right-wing patriotism. On July 4, 1939, an "Independence Day Celebration" was held at Camp Nordland—a program heavily laden with patriotic American songs but also with German *lieder*, including "Nur der Freiheit gehoert unser Leben" (Only Freedom Belongs in Our Life). The introductory speaker was the Reverend John C. Fitting, New Jersey State Bund secretary, who introduced other speeches such as "Danger in America" and "Face the Question of Communism." The advertisements on the back of the flyer list German Folks Day in New Jersey, Youth Sport Day, *Tag der Deutschen Frau* (Day for the German Woman), Harvest Thanksgiving and Nordland Youth Camp. Reverend Fitting later surfaced in New Jersey history as one of Bruno Hauptmann's spiritual advisers during the Lindbergh kidnapping case.

It is simplistic to assume that Kuhn and his band of followers were true Hitler supporters for the nationalistic German cause. A close reading of the material this group produced—if it can be stomached—reveals a theme of hate under the guise of patriotism, appearing as if the anti-German sentiment of the late 1930s was the only reason for this group's existence:

> *The cause for the founding of our Bund was the anti-German atrocity and boycott propaganda and the undermining of the interests of Americans of German ancestry. Our reaction to this un-American manipulation was the creation of "Friends of the New Germany," which was the forerunner of the present-day "German American Bund." You all know how this*

*campaign of hate has developed since 1933, when a foreign government in Central Europe, whose affairs are none of our business, was changed. In those days, not one determined voice of protest against the Jewish hate campaign could be heard from any of those existing numerous German American societies. Today, the German American Bund has been selected by the overwhelming majority of all Americans of German descent.*[73]

Kuhn's "success" is seen in the anti-German feelings that still are present in the modern era creating the Nazi Bunds as the poster child for Anti-German and not Anti-Nazi feelings. Fritz Kuhn, the self-appointed führer, was arrested first on Thursday, May 25, 1939, for forgery and grand larceny. District Attorney Thomas E. Dewey called him "just a common thief" for stealing money from his own Bund and from the proceeds of the notorious German Day Rally at Madison Square Garden.[74] Kuhn was arrested again in 1940:

Des Moines Register, *October 11, 1940*
*Indict Bund Chiefs for Attacking Jews*

*Newton, N.J. (AP)—Wilhelm Kunze, national leader of the German-American Bund, and nine others were indicted Thursday on charges of "promoting hatred against people of the Jewish religion." The Sussex County grand jury, in session about eight miles from the Bund's Camp Nordland at Andover, returned true bills which attributed to the defendants speeches including the following messages: "The real fifth column in this country is Roosevelt and his Jewish bosses. This country was founded on Irish muscle and German brain; the Jews did nothing but have everything." "Before Rosenfelt [sic] can move, Hitler will be lunching in Buckingham palace." "There are 30 million of us in this country, all Aryans." The indictments, handed up by a jury composed of 16 rural businessmen and eight housewives, climaxed an investigation conducted by Sheriff Denton J. Quick of activities at Camp Nordland. Named in the indictment, in addition to Kunze, were August Klapprott, eastern Bund leader; Matthias Kohler, state Bund treasurer; Wilbur V. Keegan, Bund attorney; Leonard D. Clark, writer for the Bund magazine* Free America; *the Rev. John C. Fitting, state Bund secretary; and Richard Schiele, Paul Schaar-schmidt, Carl Schipphorst, and George Neuppert, trustees of the Bund's auxiliary, owners of the camp.*

Sheriff Quick had built a clear case of anti-American activities, and most of the indicted were jailed or deported. Kuhn was imprisoned in a Texas internment camp and in 1946 was returned to Germany, where he was put in prison until shortly before his death in 1951.

At the hearings of the House on un-American propaganda, when asked about German American support of the Bund movement, Bund infiltrator John C. Metcalfe said, "I would say that at least 90 percent of the German American element in the United States is bitterly opposed to the activities of the German American Bund and all it stands for."[75]

# Chapter 8
# Post World War II

The years between 1915 and 1945 overshadowed the positive cultural, scientific and artistic contributions made by German Americans during 270 years in their new country. They had worked the land and built farms, pioneered new territory, established churches, joined the military and fought for their new homeland. However, the face of Hitler and splinter American Nazi Bunds once again branded German Americans as traitors and inhuman monsters. Americans of German descent, and many born there, were sent into theaters of war in which they found themselves shooting at men who were their cousins, brothers and fathers. After the war, and in the light of the Holocaust, veterans and Congressional Medal of Honor winners Lieutenant Harold Bauer, Corporal Arthur O. Beyer, Staff Sergeant Paul J. Wiedorfer and the commander of the European theater, Dwight D. Eisenhower, all German Americans, were often overlooked as heroes. The focus instead fell on the evil actions of mad men driven by a warped sense of national pride.

Post–World War II America was a difficult time for boys and girls of German heritage to grow up. The influx of "displaced persons" from all parts of Europe to the American shores—and most of these people's loss of family, fortune and homeland—were a direct result of the programs established by Adolph Hitler in the name of Aryan supremacy and Germanic unity. The anger and hostility was indeed justified. However, children in 1945 did not understand the vitriol leveled at them. One six-year-old, in first grade in a New York Jewish neighborhood, asked his father, "Are you really a Nazi

Bastard?" This confused little boy also worshipped his German-born uncle, who was a decorated American officer that had fought in Europe.

The other problem facing German Americans in the United States after the war was the care and survival of relatives in Europe. The Holocaust survivors were the most challenged by the search for missing families; however, others also had little knowledge of the fate of relatives. Mail from Germany had been heavily censored, but conditions in the last year of the war softened. One German American family in New York suddenly discovered that the husband's sisters were living in a shared single room in Stuttgart. The two boys heard that the grandmother they had never met died of pneumonia after being denied treatment in a postwar French-zone hospital because she had been a Nazi Party member. His wife discovered that all but one of her relatives was safe, even though a family of five was living in an unheated chicken coop in northern Germany.

As the years passed, there was hope that anger, hostility and blame leveled at the Germans would fade into a painful memory, with a new generation of children reaching maturity. However, the vivid imagery of a screaming dictator killing innocents has been kept before the public by the media since the horror of the war crimes were so great that they must never be forgotten. The American-born German descendant, upon reaching adulthood, has had difficulty dealing with the "German problem." The little boy who received the mocking scorn of his classmates, now an old man who knows the real history of the period, still cannot comprehend the horrors and the complete disdain for human life concerned with the facets of World War II. Three of his relatives were Jewish martyrs at Deblin, Poland, other "Nazi" cousins died in a German uniform in Holland and still another, only seventeen years old, was wounded by the French so severely that it shortened his life. Another cousin, only sixteen years old, walked home from Russia after suffering shrapnel wounds. His German-born hero uncle, however, was highly decorated for fighting with the American army in Italy against his native country.

The image of the Nazi as a conscienceless villain has been perpetuated in many modern films. As Daniel Synder of the Entertainment Channel puts it, "Films use Nazis as bad guys for good reason: they *were* the bad guys. But too often, genocidal Germans act as cartoon crutches for storytellers looking to pit good against incontrovertible evil."[76] From the Three Stooges in 1940's *You Natzy Spy!* to *Captain America* in 2011, the character of the Nazi villain has morphed into an amoral, super violent villain with no redeemable qualities. These film and television portrayals have kept the image of the militaristic humorless German alive.

# Chapter 9

# The Cold War and the Wall

Many of the German Americans surrounding the bar or sitting at a club table in the Deutscher Club in Clark, New Jersey, or at Shützen Park in North Bergen left their homes during the mid-1950s or early 1960s. Some still have decidedly German accents and are happy to be part of an ethnic social scene; however, they rarely speak of their origins. These people were part of the Cold War immigration to the United States.

Well into early 1960, the landscape of Germany showed the results of wartime bombings. In Stuttgart, Pforzheim, and Berlin, piles of rubble were turned into a *denkmal* (memorial) and were designed to serve as symbols of the war that resulted in the destruction of 45 percent of Stuttgart and 60 percent of Pforzheim.[77] They are called *Birkenkopf*, or rubble hills. The Stuttgart locals have dubbed theirs *Monte Scherbelino* (Mountain of Shards). The memorial plaque reads, "Dieser Berg nach dem Zweiten Weltkrieg aufgetürmt aus den Trümmern der Stadt steht den Opfern zum Gedächtnis den Lebenden zur Mahnung" (This mountain piled up after World War II from the rubble of the city stands as a memorial to the victims and a warning to the living). This hill, made up of 530 million cubic feet of rubble (in contrast, the Empire State Building is 37 million cubic feet), has a hiking trail to the top, where a single cross is placed in the center of a worship space.[78] At the peak, the city of Stuttgart is fully visible, and one war veteran, a Russian prisoner of war, sadly said that the mountain "was built as a reminder never to let it happen again." The pieces of houses and buildings placed along this trail were visible in 1959, when carved stone lintels and elaborate broken

architectural columns lined the trail. Today, most of these are overgrown and protrude through the growth, symbolic of a fading memory.

Destruction of the homeland led to the immigration to other countries. The difference this time was that the destinations were countrywide. Germans with relatives in New Jersey came to New Jersey.

### German Immigrants into the United States

| Years | Number | Percentage of Total Immigrants |
|-------|--------|-------------------------------|
| 1950–1959 | 576,905 | 23.1% |
| 1960–1969 | 209, 616 | 6.5% |
| 1971–1980 | 66,000 | 1.5% |
| 1981–1988 | 55,800 | 1.2 % |

People from the eastern part of the country were able to leave if they had relatives elsewhere, but the construction of the Berlin Wall in 1961 ended that. When the wall came down in 1989, there still was very little departure because the United States' immigration laws had become much stricter. Most movement was business related, and for all practical purposes, immigration had come to a halt.

The decrease in immigration led to dissolution of cultural enclaves as they were during the late 1950s and 1960s. Church services in German, once present in Jersey City, Newark and Trenton, are now gone. Schützen Park went the way of all "developed" land, German bakeries, butchers and restaurants are also fewer in number. The impact of the Internet, however, has provided virtual German centers. German music, once available only on local radio shows such as the *Munzenmaier Pumpernickel Stunde*, can now be heard on live Internet radio streaming directly from Germany. *Antenne Bayern* web radio (www.antenne.de) bills itself as "Das beste aus den 80er, 90er und den Hits von heute—Der Super-Mix von A-Z Antenne Bayern-Bayerns meiste Musik!" (The best of the '80s, '90s and today's hits—the super mix most of Bayern-Bavaria AZ antenna music!) If a German expatriate wants to meet fellow countrymen, he or she can go to the website www.internations. org, sign up and find "USA Events for Expats." Shoppers can go to www. germancorner.com and find most anything German in their area.

Like all others in the modern community, the German American has entered the electronic age and created Internet connections. Facebook provides the ability of connecting and wishing a happy birthday to a cousin in Heiligenstedener, Germany, or one can use Skype for a more personal interaction.

# Chapter 10

# In Search of *Gemütlichkeit*

When the word *gemütlich* or *gemütlichkeit* is used by a German or German American in an English sentence, someone will usually ask what it means. Usually, the answer is, "It can't be translated." Dictionary definitions include "cozy," "snug," "comfortable," "friendly," "relaxed," "leisurely" and "unhurried"; however, every German and German American knows exactly what it is. It is a feeling. The German culture holds family gatherings, good friends and good times in their hearts and memories. There is a need to rekindle this feeling on a regular basis; therefore, all immigrants and future generations created institutions that would promote *gemütlichkeit* in their lives.

The early German settlers were, as all immigrant groups are, very clannish, living near each other and grouping in areas of the larger cities. As the years passed and each generation became assimilated into the mainstream of the culture and intermarried with other ethnicities, the need for native-speaking clubs and organizations faded. The war years put a stop to German American activities, clubs and organizations; however, modern investigations into family roots have brought a new sense of the need to recognize and find ancestral connections to a personal heritage. German-speaking immigrants are no longer coming to American shores; however, a large population has discovered family foundations in all parts of the continent. American troops in postwar Germany have increased the number of African American Germans, and people are trying to reconnect to the good and positive traditions of their lineage. The first German clubs often included a clubhouse, where members could gather for recreation,

Oktoberfest at Germania Park, Dover, New Jersey. *Photo by Tina Gehrig.*

card games and beer and speak their own language. The functions of these organizations were first based on social life, music or athletics.

In 1835, the Philadelphia Männerchor (men's choir) was founded and lasted until 1962. Singing societies sprang up on the East Coast, and traveling choirs began to sing at festivals starting in 1849. In 1850, all the choirs of the societies joined into a singers union and started holding annual concerts. The New Jersey choirs became a part of the Nordörstlicher Sängerbund von Nordamerika (Northeastern Singing Club of America). Today, the Sängerbund is in full force, but as its website notes:

> *World War II once again halted these boom years. This time, the anti-German sentiment was so great that the IRS went so far as to declare the NASB an "unpatriotic organization" in 1944 and took away our non-profit status. Similarly, local choruses were challenged as un-American. The IRS' declaration could have been fatal to the NASB, but an appeal documenting the participation of German Americans in the war effort against Germany was successful. The IRS recanted, and the national festivals resumed in*

*1949, with Chicago hosting the 100th Anniversary Song Festival. Four of the songs were presented by the female singers. In 1949, records show that the women's choruses organized and elected Wilhelmine Schwartz as their first president.*[79]

There are eight choirs left in New Jersey, still singing in both German and English, as they have been since the turn of the nineteenth century. They still gather in a large concert once every ten years in Pennsylvania. Most of them have a *Liederabend* (song night) in their respective German clubhouses and then perform a more formal concert later in the year. Many of the sponsoring societies were originally limited to men only but later added a *Damenchor*. The German love of music, both *Volkslieders* (folk songs) and the more serious liturgical music, provides the audience and the sponsorship for these societies.

German clubs were formed in the middle of the nineteenth century and continue to flourish today. They started for different reasons. Some generated from the ethnic subcultures of the neighborhood, while others were started by wealthy business leaders. One example of this is Germania Park in Dover, New Jersey.

Paul Guenther, from Geithain in Saxony, Germany, immigrated to Dover in 1890. A farmer by trade, he worked in silk mills until he conquered the process and opened his own manufacturing company by renting space from the Swiss Knitting Mill on Spruce Street in Dover. As it became more successful, he moved the business to a massive factory he built on King Street. He expanded the mill and added several more buildings and a bridge over

Germania Park. *Photo by the author.*

the street. By 1920, he employed over one thousand workers, mostly women, and built housing, a church and, finally, a German club in what was then called Germantown. He helped establish the Deutsche Vereinigung Dover, which has since become Deutscher Schul und Gesang Verein. Guenther was instrumental in constructing a park, including a chalet and a beer garden. Today, the club, as do many others in the state, hosts concerts, weekend get-togethers and an annual Oktoberfest.

German social clubs initially provided a social outlet for German Americans, but there is now a more diverse population for them to serve. Membership in the Schlaraffia society, however, requires fluency in German, as it is a worldwide German-speaking society. It is an offshoot of the larger clubs, which were founded in Prague in 1859, and is now worldwide, with a membership over eleven thousand men. Meetings, called *Sippungen*, are held weekly between October 1 and April 30 in a medieval castle setting, or *Schlaraffen*, at each of the local clubs (*reychs*). The gatherings offer satire, good humor and fellowship and include a special "pig Latin" language. The New Jersey branch is called *Schalarafia Newarka*.

The Steuben Society of America has two branches in New Jersey, each one named after celebrated German Americans Molly Pitcher and Peter Muhlenberg. These organizations meet monthly with an aim to:

> *educate the public about matters of interest to American citizens of German descent and their families, to encourage participation in civic affairs, and to perpetuate and enhance the understanding of contributions made by such citizens to the development of the United States of America. In appealing to newly made citizens, as well as to descendants of immigrants from Germany, Switzerland, Austria and other German-speaking areas of Europe, the founders called "Duty, Justice, Charity, and Tolerance" the four pillars on which the society is built.*[80]

The revolution in Germany in 1848 also brought a series of clubs across the United States called Turn-Vereins or simply "Turners." Friederich Jahn established the first Turn-Verein movement, which "advocated strengthening the mind and body through gymnastic instruction." The clubs, which also included a meeting and a cultural center, are credited with introducing the now-required physical education in public schools. There are two left in New Jersey: Carlstadt Turn Verein and Plainfield Gesang Turn Verein.

The most popular German American sport, however, is soccer or, *Fussball*. The advent of developmental soccer clubs and teams has put an end to

the glory days of the sport in New Jersey. Trenton hosts one of the more lasting clubs: the German American Kickers. It was started in 1930, filled with refugees from the post–World War I immigration, and was an adjunct group to the Trenton Liederkranz (singing society). It is currently sponsored by Deutsch Amerikanische Vereinigung (German American Society). It suspended activities during World War II but started again in 1950. Soccer was not as popular then as it is today, and most Americans then viewed it as a foreign sport. In those years, players wore steel-toed shoes and baggy shorts and ran five to the front line and three on defense on bumpy fields in Kearny, Harrison, Passaic, Hoboken, Elizabeth and Newark. Elizabeth Sports Club, founded in 1924, produced Manfred Schellscheidt, the first coach to be granted an A-1 license by the United States Soccer Federation and who as a player won two U.S. Open Cups. The old fields are gone now, having been replaced with modern facilities focused on youth soccer.

# Chapter 11

# German Institutions

New Jersey has hosted longtime German institutions for many years, including newspapers, restaurants, pork stores, bakeries and folk festivals. With the assimilation of the first-generation German Americans, there is less of a need for German specialty food stores. But that does not mean that there is no need for ethnic festivals. There are nineteen or more Oktoberfests in New Jersey, along with clubs' Jaegerfest (hunter's festival) and Schlachtfest (pork festival), which is a traditional German celebration held after the slaughter of the farmer's family pig. A *Schlachteplatte* of pork, cooked blood and liver sausage accompanied by sauerkraut or potato pancakes is washed down with a good local beer. Most of the German clubs sponsor one or two of these per year.

Many of the New Jersey clubs also sponsor German shows featuring live entertainment from the Old Country. They are usually performed around Christmastime and again in the spring. Small groups of entertainers travel along the East Coast from club to club primarily performing the "old songs" and *Schlager* (hits).

There are a few remaining bastions of food sources in the tradition of the "good old days." The German pork store, or *Deutsches Würst Geschäft*, was once widely found in ethnic neighborhoods, producing homemade smoked sausage, cold cuts and salads. A true butcher, while cutting his product, was in full view of the customers, who could carefully watch what he was doing. In a true delicatessen (a circa 1889 German "loanword" from *Delikat* [delicacy] and *Essen* [to eat]), other ethnic products, including candy, were

*Above*: Schlachtfest cooks in the kitchen. *Courtesy of the author.*

*Right*: A Schlachtfest dinner at Germania Park. *Courtesy of the author.*

German entertainers performing during a Christmas celebration at the German Club in Germania Park. *Courtesy of the author.*

laid out on shelves with other traditional "feel-good food." There are only a few of these shops left, probably because many of today's supermarkets now carry the same products. However, one example is still to be found in tiny Blairstown, New Jersey, on one of the few main streets. Alpine Meats and Deli, owned by German-trained butcher Roy Pridham and his wife, Britta, make homemade sausages from scratch and have a weighing and butchering station for hunters in the area.

Many of the German restaurants in New Jersey have also closed, although there are a few remaining in Hoboken and South Jersey. The proprietors at *Black Forest Inn* in Stanhope, New Jersey—Heinrich, Elke, Heiner Aichen and Barbara Aichem-Koster—provide traditional folk and wild-game festivals and serve traditional cuisine as well as the usual "brats and wursts." The restaurant, which holds weekly specialty buffets, prides itself in promoting the heritage while working to keep the much sought after *gemütlichkeit* during Oktoberfests and heritage fests.

Traditional German bakeries, found on every corner in Germany, have all but disappeared in New Jersey communities. The reason is not disinterest

Alpine Deli and Meats, Blairstown, New Jersey. *Courtesy of the author.*

The interior of Alpine Meats and Deli. *Courtesy of the author.*

in baked goods but rather due to the ease of shopping in the large markets. German-based stores offer traditional food and baked goods, including some of the traditional Christmas cookies and stollen. The German firm ALDI

Black Forest Inn, Stanhope, New Jersey. *Courtesy of the author.*

The dining room of the Black Forest Inn. *Courtesy of the author.*

originated in 1913 in Essen, Germany, when Karl and Theo Albrecht's mother opened a small store in a suburb of the city. At the conclusion of World War II, the brothers opened a retail grocery store that by 1950 had expanded to thirteen stores in the Ruhr Valley. Their concept was to keep a small retail store with savings passed on to the customer. In 1960, the brothers split after an argument over the sale of cigarettes and changed the name from Albrecht's to ALDI (Albrecht's Diskount). They then split into ALDI Nord and ALDI South and expanded internationally after the reunification of Germany. Today, there are 1,200 ALDI stores in the United States, along with a subsidiary of 355 Trader Joe's, all of which follow the same practices of metal gates and turnstiles forcing an exit through the checkout. The stores do not accept credit cards passing along the saving to the customer, and they also originated the shopping cart–rental policy along with a no-bag policy.

The other German market is A&P, an American institution that was purchased by Erivan Haub, owner of the German chains of Plus and Tengelman's. The new owners changed the face of the old stores, adding a "fresh market" section and marketing their own products. They also carry Schaller and Weber German meats and wursts, making those German staples more available to the communities.

One of the most beneficial and affordable senior care facilities in New Jersey is the Fritz Reuter Altenheim, which provides senior living, assisted living and constant care for the elderly on a low-cost basis. It is the only volunteer non-profit home in the state. The namesake of the home, Fritz Reuter, was a German novelist of some distinction. At the foot of the

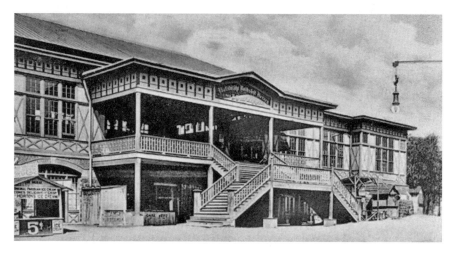

Schützen Park, North Bergen, New Jersey. *Courtesy of the author.*

building is the Schützenverein, a Plattdeutsch club originally for people from northern Germany that provides a social setting for the residents of the facility and the community. Potential residents must be over the age of seventy, able to walk and able to afford the entrance fee. From that point onward, their care, from independent living to constant care if needed, is assured. The building, constructed in 1895, sits on a hill in North Bergen and is connected to a shopping mall by an underground tunnel. For years, the home was 80 percent German but now includes all nationalities.

According to a chamber of commerce report of a few years ago, over thirty-six thousand people work for German-based companies in New Jersey. Among the largest of those companies are:

BASF, Florham Park,
BMW of North America, Woodcliff Lake;
Great Atlantic and Pacific Tea Co., Montvale
Evonik Degussa Corp., Parsippany
American Water Works Co., Voorhees
Linde Gas, Murray Hill
Hapag Lloyd Inc., Piscataway
EMD Chemicals, Gibbstown

# Chapter 12
# Artistic and Well Known

Gerrman Americans have contributed to the development, history and growth of their adopted state in all aspects of life. They can be found in the military, performing arts, science and industry. Following are some of the more notable German Americans with New Jersey connections.

## Major General Friedrich Wilhelm Baron von Steuben

Born in Magdeburg, Germany, in 1730, Friedrich Wilhelm von Steuben was one of the most famous German contributors to the American Revolution. He organized the American Continental army using a chain of command that is still in use in today's military. He also wrote the *Revolutionary War Drill Manual*. After the war, while he lived in New Bridge (River Edge), New Jersey, von Steuben was given American citizenship. He eventually moved to Rome, New York, where he passed away.

Major General Baron von Steuben. *Library of Congress.*

## Theodorus Jacobus Frelinghuysen

Born in Lingen, East Friesland, Germany, in 1691, Theodorus Frelinghuysen settled in the Raritan Valley in New Jersey, where he was the father of the First Great Awakening.

## General Frederick Frelinghuysen

Frederick Frelinghuysen was a Revolutionary War general, a delegate to the Continental Congress and a United States senator. He was the Grandson of Theodorus Frelinghuysen.

## John Roebling

John Roebling, a famous inventor and engineer, invented the suspension bridge and was the architect of the Brooklyn Bridge. Born in Mühlhausen, Germany, he came to America in 1831. The town of Roebling, New Jersey, is named after him, and his steel cable factory was housed there. Before he built the historic Brooklyn Bridge, Roebling built smaller bridges in the area. The only one that remains is the Delaware Aqueduct, near Lackawaxen, Pennsylvania. The first of its kind, it was built in 1849 at a cost of $41,750. Roebling died due to an accident he suffered while surveying the site of the tower for the Brooklyn Bridge.

Roebling's suspension bridge across the Delaware. *Courtesy of the author.*

## Washington Roebling

A survivor of the Battle of Gettysburg, Washington Roebling finished his father's Brooklyn Bridge after his service in the Civil War as an engineer. He completed the bridge in 1883.

## Thomas Nast

Thomas Nast, the father of the American cartoon, was born in Landau, Germany, in 1840, but his father, who had political issues, moved the family to New York City, where Thomas studied art. Nast started out as an illustrator for *Frank Leslie's Illustrated Magazine* before moving to *Harper's Weekly*, where he achieved fame during the Civil War. His most famous images were of Santa Claus and the Republican elephant. His political cartoons forced the exposure of the Boss Tweed Ring, advocated the abolition of slavery and appealed to the plight of the Native and Chinese Americans.

Thomas Nast. *Library of Congress.*

## Johann Peter Rockenfeller

Johann Rockenfeller was born in the town of Rockenfeld in the suburb of Neuwied in the Rhineland-Pfalz region. He was a farmer near Somerville, New Jersey, and is buried in Hunterdon County. He is the progenitor of the famous Rockefeller family in the United States.

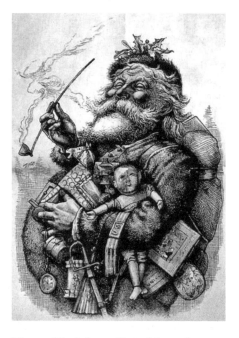

Thomas Nast's Santa Claus. *Library of Congress.*

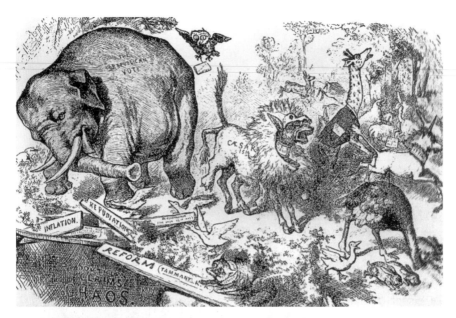

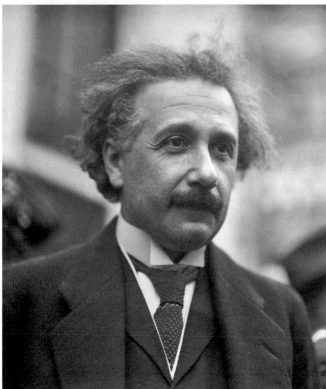

*Above*: Thomas Nast's Republican elephant. *Library of Congress*.

*Left*: Albert Einstein. *Library of Congress*.

### Albert Einstein
One of the most famous German ex-patriots (and whose name became synonymous with genius), Albert Einstein was born in Ulm, Germany, but remained in Princeton, New Jersey, after a visit to the United States.

### Peter Dinklage
Peter Dinklage was born, raised and schooled in Morris County. He is a star of film and television and is of German American descent.

### Meryl Streep
Meryl Streep is an Academy Award–winning actor from Summit, New Jersey.

### Bruce Willis
Film star Bruce Willis was born in Kaufungen, Germany, near Kassel and was raised in Carney's Point, New Jersey.

# Chapter 13

# Today's World

In the modern world of "diversity," the teaching of the German language had been curtailed for several years because of the World Wars. First-generation German Americans did not speak their parents' languages at home because of national paranoia regarding the "enemy," as well as the fear of producing children, in America, who were "too German" and who would speak English with a foreign accent.

Recently, the German American culture has seen a revival, with parades, celebrations and festivals all taking place; however, on a lesser scale, anti-German sentiment remains. The remnants of the ugly war years simmer beneath the surface of modern society in the minds and politics of a few small fringe groups. Film writers characterize the archetypical evil villain as Nazis, who otherwise might have faded from view, and can draw them more one-dimensional than they really were. The memory of who they really were should not be lost.

Many notable people of German descent or heritage pass through the Garden State. Most of the modern immigrants come for job-related reasons. Sometimes they stay, and sometimes they do not. The study of the German language has been reinstated in many high schools, which have also added German clubs as part of their extracurricular activities. Young people, two generations distant from the war years, are seeking their roots both on line and with travel.

German club festivals have had a recent resurgence. *German Life* magazine (in English) has advertisements of nationwide Oktoberfests. The Steuben

Day Parade in September is the longest ethnic parade in New York City and is now broadcast on PBS. On the same day, there is a German Catholic Mass in St. Patrick's Cathedral in the city. After parading up Fifth Avenue past a row of dignitaries who have included Henry Kissinger, Dr. Ruth Wertheimer, Siegfried and Roy, Mayor Michael Bloomberg and many others, participants are invited to go to Central Park for the largest Oktoberfest in the area. Many of the German clubs host bands from the other side, and everyone on the parade route of German descent—whether by blood or by adoption—waves miniature German and American flags. Proud Germans, now American citizens, have been seen weeping openly as the American flag passes by. The mixed ethnicity of the city is apparent when the South American Spanish-speaking German club marches up the avenue followed by the NYPD German band with an African American tuba line.

The conflicts of the war years are more than half a century away, and with the exception of those holding on to hatred and animosity, most people are looking forward, hoping to discover the best in their culture and heritage that applies to their own life. It is important to respect the sacrifices made by many of our forebears and to understand a heritage that influenced our own upbringing and lifestyles.

*I love this country, and I am only sorry that I was not born here.*
*—Heinz (Harry) Dietrich Lubrecht, 1931 Diary*

# Appendix

## Early Palatine Immigrant Towns of Origin in Germany

Bendorf

Bruckhausen

Dierdorf

Edigen

Ehlscheid

Eppelnheim

Fahr

Feldkirchen

Halberstadt

Handschuhsheim

Kirchheim

Koblenz

Laimen

Landau

Neckarhausen

Neuwwied

Niederbieber

Nussloch

Rockenfeld

Segendorf

Uhrbach

Wieblingen

Wissluch

Wolfenbüttel

**Captured Hessians at Mount Hope**

| Soldier | Age | Home | Regiment/Commander | Year(s) spent as a POW |
|---|---|---|---|---|
| Private Henrich Angersbach | 39 | Oberaula | Von Dechow | 1777 |
| Private Adolf Assmann | 28 | Prince Succesor | Hohenreiche | 1783 (deserted) |
| Private Henrich Blettner | 34 | Christerode | Von Dechow | 1777 |
| Private Sigmund Bressler | unknown | unknown | Von Dechow | 1779 |
| Private Kurt Conrad | unknown | Leib | unknown | 1777 |
| Private Konrad Corell | 27 | Merzhausen | Von Biesewnrodt | 1782 |
| Corporal Conrad Daube | 37 | Niedergrenzenbach | Leib | 1777 (returned to Europe) |
| Private Wigand Dirlam | 19 | Ottrau | Von Dechow | 1777 and 1779 |
| Cannonier Peter Eichmann | 22 | Bochenheim | Third Hesse-Kassel Artillery | 1777 (deserted) |

| Soldier | Age | Home | Regiment/ Commander | Year(s) spent as a POW |
|---------|-----|------|---------------------|------------------------|
| Private Johann Engeland | unknown | Schoenau | Von Biesenrodt | 1779 and 1782 |
| Corporal Nikolas Fenner | 27 | Neukirchen | Von Borck | 1779 |
| Private Heinrich Gimbel | 24 | Riebelsdorf | Loeb | 1777 |
| Private Justus Henrich Gleubert | 29 | Leib | Obergrenzenbach | 1777 |
| Corporal Jacob Goercke | 44 | Oedelsheim | Von Dechow | 1777 |
| Private Georg Hahn | unknown | Nausis | Von Dechow | 1777 |
| Private Paul Haust | 26 | Wasenburg | Leib | 1777 |
| Private Valentin Landau | 36 | Wahlshausen | Von Dechow | 1777 and 1779 (ransomed/bought his freedom) |
| Bombadier Wilhelm List/ Liste | 25 | Harrenshausen | Hesse-Hanau Artillery | 1782 |

| Soldier | Age | Home | Regiment/Commander | Year(s) spent as a POW |
|---------|-----|------|--------------------|------------------------|
| Private Claus Henrich Mueller | unknown | unknown | Von Borck | 1777 |
| Canonier Jacob Peter | 24 | Beisefoerth | Third Hesse-Kassel Artillery | 1777 (bought his freedom) |
| Private Johann Andreas Pfeiffer | 39 | Hedemuenden | Leib | 1782 |
| Private Henrich Priester | unknown | Dittershausen | Von Biesenrodt | 1779 |
| Private Henrich Quaehl | 26 | unknown | Von Dechow | 1777 |
| Corporal Philip Roeder/Roether | 45 | Sterbfritz | Von Dechow | 1777 (escaped to New York) |
| Private Georg Schmidt | 26 | unknown | Von Biesenrodt | 1777 |
| Private Georg Henrich Schmeider | unknown | unknown | Leib | 1777 |
| Private Henrich Schnuecker | 26 | Schorbach | Von Dechow | 1777 |

| Soldier | Age | Home | Regiment/ Commander | Year(s) spent as a POW |
|---|---|---|---|---|
| Private Dietrich Schultheiss | 29 | Schorbach | Von Dechow | 1777 and 1779 (ransomed) |
| Private Henrich Schultheiss | 16 | Salmshausen | Von Borck | 1777 |
| Private Johannes Speichert | 24 | Gilserberg | unknown | 1777 and 1779 (returned) |
| Private Wilhelm Steinbrecher | 27 | Merzhausen | Leib | 1777 |
| Private Johannes Wiest | 25 | Niedergrenzenbach | unknown | 1777 |
| Private Johannes Wilke | unknown | unknown | Von Dechow | 1779 |
| Corporal Johannes Wohlgemuth | 24 | Niederaula | Von Dechow | 1777 |
| Private Leopold Zindel | unknown | unknown | Erbprinz | 1777 |

## Prominent Newark German American Citizens Who Fled from the German Revolution of 1848

| Name | City of Origin | Occupation | Life in Newark | Prison Sentence in Germany |
|---|---|---|---|---|
| Arthur Balbach | Baden | army captain | topographer | none |
| August Camerer | Baden | surveyor | surveyor | two years |
| Dr. Fridolin Ill | Überlingen | physician | first doctor of the German hospital | six years |
| Dr. Louis Greiner | Bavaria | professor | attorney | Death |
| Conrad Hollinger | Baden | writer | editor for *Der Nachbar* German newspaper | one hundred years |
| Conrad Katzenmeyer | Constanz-Baden | administrator | administraor | ten years |
| Charles Kiesele | Carlsruhe | veterinarian | veterinarian | two years solitary confinement |
| Reverend Frederick August Lehlbach | Ladenburg-Baden | minister | minister | solitary confinement |
| Dr. Emil Schuiffner | Mittwayda-Saxony | attorney/judge | attorney | fled |
| Franz Umbscheiden | Gruenstadt-Bavaria | writer | editor of *New Yorker Staats Zeitung* | death |
| Charles T. Ziegler | Baden | attorney | attorney | ten years |

## German American Clubs and Organizations in New Jersey

Arbeiter Männer and Damenchor, 151 East Frankin Street, Trenton

Cannstatter Volksfest Verein NJ/NY, 2 Autumntide Drive, Lakewood, 732-279-0733

Carlstadt Active Turners and Mixed Chorus, 500 Broad Street, Carlstadt, 201-438-9644

Deutscher Club of Clark Inc., 787 Featherbed Lane, Clark, 732-574-8600

Germania Park Deutscher Schul und Gesang Verein, Conger Street, Dover, 973-328-9693

Plainfield Gesang- und Turnverein Inc., 220 Somerset Street, North Plainfield, 908-755-8878

Plattdeutsche Volksfest Vereen of New York and New Jersey (Schuetzenpark-3167), Kennedy Boulevard, North Bergen

### Steuben Societies

Molly Pitcher Unit #54, Lakewood Manor Männerchor, Lanes Mill Road, Howell

Peter Muhlenberg Unit #398, Deutscher Club, 787 Featherbed Lane, Clark

## Early German American Industries in New Jersey

Johann Faber, manufacturing, Eberhard Faber Pencil Co., Newark

Christian Feigenspan, brewing, Christian Feigenspan Brewing, Newark

Peter Hasenclever, iron, American Iron Company, Ringwood

Frederick Heller, chemicals, Heller & Merz, Newark

August Loehnburg, leather tanning, Kaufherr & Co., Newark

Wilhelm Keuffel, manufacturing, Keuffel & Esser, Hoboken

George Merck, pharmaceuticals, Merck & Co., Rahway

Henry Merz, chemicals, Heller & Merz, Newark

# Notes

## Introduction

1. Jost, "More German Than You Think."

## Chapter 1

2. Kübel, *Die Familie Kübel.*
3. Ibid.
4. Penn, *Some Account of the Province of Pennsylvania.*
5. Mittelberger, *Reise nach Pennsylvanien,* 16.
6. Ibid., 18.
7. Ibid., 19.
8. Ibid.
9. Mellick, *Story of an Old Farm,* 151.
10. Ibid.

## Chapter 2

11. Bittinger, *Germans of Colonial Times.*
12. Howe and Barber, *Historical Collections.*
13. Mellick, *Story of an Old Farm,* 92.

14. Justus Falckner is chronicled as the first Lutheran pastor in the areas of New York, New Jersey and Philadelphia.

15. Goodfriend, *Before the Melting Pot.*

16. Ibid., 90.

17. Mellick, *Story of an Old Farm*, 98.

18. Mellick, *Hessians in New Jersey*, 109.

19. Ibid., 100.

20. Ibid., 284.

21. Minutes of the Provincial Congress, 25–27.

22. Mellick, *Hessians in New Jersey*, 323–24.

23. Howe and Barber, *Historical Collections.*

24. Schaeffer, *Stillwater*, 7.

25. Frelinghuysen, *Early Germans of New Jersey*, 98.

# Chapter 3

26. Franklin, *Autobiography.*

27. Ibid.

28. The Single Sisters' House in Bethlehem.

29. Paull, *Moravian Women's Memoirs.*

30. Schweinitz, *The Moravian Manual.*

31. Beckel, *Early Marriage Customs.*

32. Hope Historical Society, *The Moravian Contribution to the Town of Hope*, 4.

33. Murray, *A Bicentennial Picture Book of Hope.*

# Chapter 4

34. Mellick, *Hessians in New Jersey*, 9.

35. Fold3.com, "Hetrina: Major Desertions."

36. Woelfel, "Memoirs of a Hessian Conscript."

37. Reuter, *Die Braunschweigischen.*

38. Miles, "The Iron Master," 38.

39. Ibid., 22.

40. Ibid., 27.

41. Stevens et al, "Report on American Manuscripts."

42. Miles, "The Iron Master," 106.

43. Ibid.

44. Ibid.

45. Shafer, *Stillwater*, 75.

46. Avalon Project, "Articles of Convention Between Lieutenant-General Burgoyne and Major General Gates, October 16, 1777." http://avalon.law. yale.edu/18th_century/burgoyne_gates.asp.

47. Stevens et al, "Report on American Manuscripts."

48. Becker, *The Sexagenery*, 120–22.

49. Féronce to Faucitt, December 23, 1777, in Lowell, *The Hessians*.

50. West Jersey History Project, *Plan Du Fort Knyphausen*, www.westjerseyhistory.org.

51. Intelligence, January 19, 1779, HMC, Carlisle MSS, 415.

52. Hannah Wintrop to Mercy Warren, November 1, 1777, in Warren and Adams, *Warren-Adams Letters*.

# Chapter 5

53. Atkinson, *History of Newark*, 201.

54. Ibid., 203.

55. Bond, *War and Society in Europe*, 63.

# Chapter 6

56. Greenhill, "Secret of the Lusitania."

57. Ibid.

58. Frerichs, *Personal Reminiscences*.

59. Ibid.

60. Private letter in the author's collection.

61. Family letter, courtesy of the author.

62. August Ehlers's letter to Johanne Marie Ficke, August 1934.

63. Ruth Lubrecht's letter to Heinz Lubrecht, courtesy of the author.

64. The History Place, "Hitler's Boy Soldiers," http://www.historyplace.com/ worldwar2/hitleryouth/hj-boy-soldiers.htm.

# CHAPTER 7

65. Franklin, *Observations Concerning the Increase of Mankind.*
66. Faust, *The German Element.*
67. Anbinder, *Nativism and Slavery*, 20.
68. Humphrey, *The Know-Nothing Party.*
69. Ibid., 34.
70. Faust, *The German Element.*
71. Abraham Lincoln to Joshua Speed, August 24, 1855.
72. National Archives, "Brief Overview."
73. Markmann, "Reasons for the Bund's Existence."
74. Jewish Telegraphic Agency, "Fritz Kuhn Held in $5,000 Bail as Embezzler of Funds," www.jta.org/1939/05/28/archive/fritz-Kuhn-held-in-5000-bail-as-embezzler-of-bund-funds.
75. United States Congress, *Investigation of Un-American Propaganda Activities.*

# CHAPTER 8

76. Snyder, "Nazis as Movie Villains."

# CHAPTER 9

77. There are also rubble mountains in Dresden, Frankfurt on Main, Hannover, Köln, Leipzig, Mönchengladbach, Munich (three of them) and Nuremberg.
78. Rogers, "Rubble Mountain."

# CHAPTER 10

79. See www.nasaengerbund.org.
80. See www.steubensociety.org.

# Bibliography

Anbinder, Tyler. *Nativism and Slavery: The Northern Know Nothings and Politics of the 1850s*. Oxford: Oxford University Press, 1992.

Atkinson, Joseph. *The History of Newark, New Jersey*. Newark, NJ: W.B. Guild, 1878.

Beckel, Clarence E. *Early Marriage Customs of the Moravian Congregation in Bethlehem*. Vol. 3. The Pennsylvania German Folklore Society, 1938.

Becker, John F. *The Sexagenery; Or, Reminiscences of the American Revolution*. Albany, NY: 1866.

Bittinger, Lucy Forney. *The Germans of Colonial Times*. Philadelphia: J.B. Lippincott, 1901.

Bond, Brian. *War and Society in Europe, 1870–1970*. Kingston, ON: McGill University Press, 1998.

Buettner, Johann Carl. *The Adventures of Johann Carl Buettner*. Privately printed, 1828.

Cameron, Euan, ed. *Early Modern Europe: An Oxford History*. Oxford, UK: Oxford University Press, 1999.

Chambers, Theodore Frelinghuysen. *The Early Germans of New Jersey: Their History, Churches and Genealogies*. Dover, NJ: Dover Printing Company, 1895.

Döhla, Johann Conrad. *A Hessian Diary of the American Revolution*. Edited by Bruce E. Burgoyne. Norman: University of Oklahoma Press, 1990.

Epping, Charlotte S.J., trans. *Journal of Du Roi the Elder: Lieutenant and Adjutant in the Service of the Duke of Brunswick, 1776–1778*. New York: D. Appleton and Co., 1911.

Faust, Albert Bernhardt. *The German Element in the United States: With Special Reference to Its Social and Educational Influence*. 2 vols. Boston: Houghton Mifflin, 1909.

Franklin, Benjamin. *The Autobiography of Benjamin Franklin*. Norton Critical Edition. New York: W.W. Norton & Co., 2012.

———. "Observations Concerning the Increase of Mankind, Peopling of Countries, etc." Boston: S. Kneeland, 1755.

Frerichs, Margarethe. Interview with Peter Lubrecht. May 2013.

———. "Personal Reminisces." Unpublished.

Goodfriend, Joyce D. *Before the Melting Pot: Society and Culture in Colonial New York City, 1664–1730*. Princeton, NJ: Princeton University Press, 1994.

Greenhill, Sam. "Secret of the Lusitania: Arms Find Challenges Allied Claims It Was Solely a Passenger Ship." *London Daily Mail*, December 19, 2008.

Grover, Warren. *Nazis in Newark*. Piscataway, NJ: Transaction Publishers, 2003.

Hope Historical Society. *The Moravian Contribution to the Town of Hope, New Jersey*. Hope, NJ: Hope Historical Society, 1955.

Howe, Henry, and John W. Barber. *Historical Collections of the State of New Jersey: Containing a General Collection of the Most Interesting Facts, Traditions, Biographical Sketches, Anecdotes, Etc. Relating to the History and Antiquities with Geographical Descriptions of Every Township*. Newark, NJ: S. Tuttle, 1846.

Humphrey, Desmond. *The Know-Nothing Party: A Sketch*. Washington, D.C.: New Century Press, 1904.

Jost, Irmintraud. "More German Than You Think: Every Sixth American Can Trace His or Her Roots Back to Germany." *Atlantic Times*, November 2004.

Kalm, Peter. *Peter Kalm's Travels in North America: The English Version of 1770*. Edited by Adolph B. Benson. 2 vols. New York: Dover Publications, 1966.

Knepper, George W. *The Convention Army, 1777–1783*. Ann Arbor: University of Michigan, 1954.

Kübel, Franz. *Die Familie Kübel Ihre Herkunst, ihr Stammbaum und Ihre Geschicte*. Stuttgart: von Stähle & Friedel, 1902.

Littleton, Charles, and Randolph Vigne. *From Strangers to Citizens: The Integration of Immigrant Communities in Britain, Ireland, and Colonial America, 1550–1750*. Brighton, UK: Sussex Academic Press, 2001.

Lowell, Edward J. *The Hessians and Other German Auxiliaries of Great Britain and the Revolutionary War*. New York: Harper & Brothers, 1884.

Marburg Archivschule. "Hessische Truppen im Amerikanischen Unabhängigkeitskrieg (Hetrina)." Veröffentlichen der Archivschule Marburg Institut für Archivwissenschaft 10. Band III, 1976.

Markmann, Rudolf. "Reasons for the Bund's Existence." *Free America!: Six Addresses on the Aims and Purposes of the German American Bund*. New York: Sons of Liberty, 1939.

Mellick, Andrew D. *The Hessians in New Jersey: Just a Little in Their Favor*. Trenton, NJ: New Jersey Advertiser Printing House, 1888.

———. *The Story of an Old Farm; Or, Life in New Jersey in the Eighteenth Century*. Somerville, NJ: Unionist Gazette, 1889.

Miles, Lion. "The Iron Master and the Hessians." *Journal of the Johannes Schwalm Historical Association* 2, no. 1 (1981).

Miller, Marvin D. *Wunderlich's Salute*. N.p.: Malamud-Rose, 1983.

Minutes of the Provincial Congress and the Council of Safety of the State of New Jersey. Trenton, NJ: 1879.

Mittelberger, Gottlieb. *Reise nach Pennsylvanien im Jahre 1750*. Stuttgart: 1756.

Murray, Leo P. *A Bicentennial Picture Book of Hope in Warren County, New Jersey*. Hope, NJ: Hope Bicentennial Committee, 1976.

National Archives. "Brief Overview of World War II Enemy Alien Control Program." www.archives.gov/research/immigration/enemy-aliens-oveview.html.

Paull, Katherine M., ed. *Moravian Women's Memoirs: Their Related Lives, 1750–1829*. Syracuse, NY: Syracuse University Press, 1997.

Penn, William. *Some Account of the Provinces of Pennsylvania*. London, 1681.

Popp, Stephan. *A Hessian Soldier in the American Revolution*. Privately printed, 1933.

Reuter, Claus. "Die Braunschweigischen Truppen in Nordamerika, 1776–1783." Veröffenlichungen des German-Canadian Museum of Applied History.

Riedesel, Baroness von. *Baroness von Riedesel and the American Revolution*. Edited by Marvin L. Brown Jr. Williamsburg, VA: Institute of Early American Culture and History, n.d.

Rogers, David. "Rubble Mountain Offers Striking Views of Stuttgart, Germany." *Stars and Stripes*, April 2013.

Rosengarten, Joseph G. "A Defence of the Hessians." *The Pennsylvania Magazine of History and Biography*, July 1899.

Schaeffer, Caspar. *Stillwater*. N.p.: n.d.

Schulze, Hagen. *Germany: A New History*. Cambridge, MA: Harvard University Press, 1998.

Schweinitz, Edmund. *The Moravian Manual: Containing an Account of the Moravian Church, or Unitas Fratum*. Bethlehem, PA: A.C. and H.T. Clauder, 1869.

Snyder, Daniel. "Nazis as Movie Villains: The Evolution of a Cliché." *Atlantic Monthly*, July 26, 2011.

Stevens, Benjamin Franklin, et al. "Report on American Manuscripts in the Royal Institution of Great Britain." London: Mackie and Co., 1906.

United States Congress. *Investigation of Un-American Propaganda Activities in the United States*. Washington, D.C.: U.S. Government Printing Office, 1938.

Warren, James, and Samuel Adams. *Warren-Adams Letters: Being Chiefly a Correspondence Among John Adams, Samuel Adams and James Warren*. 12 vols. Boston: Massachusetts Historical Society, 1917–1925.

Woefel, Margaret. "Memoirs of a Hessian Conscript: J.G. Seume's Reluctant Voyage to America." *The William and Mary Quarterly* 5, no. 4 (October 1948): 553–70.

# Index

# INDEX

# About the Author

Dr. Peter Lubrecht has a PhD in educational theater from New York University and a master's degree in English and drama theory from NYU's Graduate School of Arts and Science. As a result of his studies, he has been giving papers internationally on youth theater, historical Shakespeare productions from the actor's point of view, theatrical pedagogy, research, writing and youth and school productions. His travels as a presenter have taken him to the University of Roehampton in London, the University of Portsmouth, Southern Utah University, Toronto and his alma mater in New York for international Shakespeare conferences. An avid researcher with an interest in historical theater, Lubrecht has been lecturing locally on the Civil War and nineteenth-century American theater for the past thirty years.

Peter is originally from New York City, where he appeared in and was a part of an experimental theater program conducted by the New York Public

Schools, under whose aegis he studied acting with Harold Jackson of the Harlem Renaissance. He was featured as a guest on NPR at age nine. His early television production experience began at NYU, where he finished while working on Harry Salter, Jackie Gleason and Merv Griffin productions.

Peter is currently an adjunct professor of English, speech and theater at Warren County College in Washington, New Jersey. In the past, has taught at Lehman University Graduate School; New Jersey City University; and Bergen, Morris and Passaic Community Colleges. He finished his high school teaching career as a drama teacher at the Cecily Tyson School of Performing Arts. His last book for The History Press was *New Jersey Butterfly Boys in the Civil War*, about the Third New Jersey Cavalry.

*Visit us at*
www.historypress.net

*This title is also available as an e-book*